THE ARCHAEOLOGY OF WORCESTER IN 20 DIGS

James Dinn

AMBERLEY

Front cover, top: Nineteenth-century kiln at Grainger's Porcelain Works (Dig 19); *bottom*: Excavation at Cathedral Square (Dig 20). (Photographs reproduced courtesy of Worcestershire Archive and Archaeology Service)

Back cover: Digging for Roman treasure at Worcester Castle (Dig 1). (Photograph by Mr Christopher Guy, Worcester Cathedral Archaeologist. Reproduced by permission of the Chapter of Worcester Cathedral (UK))

First published 2024

Amberley Publishing
The Hill, Stroud
Gloucestershire, GL5 4EP

www.amberley-books.com

British Library Cataloguing in Publication Data.
A catalogue record for this book is available from the British Library.

ISBN 978 1 4456 9402 3 (print)
ISBN 978 1 4456 9403 0 (ebook)

Typesetting by SJmagic DESIGN SERVICES, India.
Printed in Great Britain.

Contents

Introduction

It is often said that Worcester is a quintessential English historic city. Grand buildings bear witness to sustained prosperity for some sectors of society in the eighteenth and nineteenth centuries. There are the trappings of medieval wealth and power, including the cathedral and city walls. The '-cester' place name shows that its Roman past was recognised by the Anglo-Saxons. But Worcester's origins go back much further.

In this book we will discover twenty excavations through which the stories of Worcester's origins and development, and the lives, work and death of its citizens, have gradually been rediscovered – work still in progress. Prehistoric origins are preserved in a massive earthwork rampart and ditch, buried deep beneath the modern townscape. Roman evidence is ubiquitous, and archaeology has revealed buildings, streets, industry and farming. Roman Worcester has emerged from a nebulous place of stray finds and disconnected features, to become a substantial 'urban' centre, though archaeologists continue to debate whether it can truly be called a town. Interventions by church and state in the Anglo-Saxon and Norman periods ensured Worcester's survival, at the centre of the county of Worcestershire. The medieval city boasted monastic houses and a dozen churches, a castle, and stone gates and walls, as well as the cathedral and its priory. Outside the walls, industrial suburbs flourished. The evidence of industry is key to Worcester's story, and there could be thousands of tonnes of Roman iron slag alone. Many digs have revealed traces of the use of fire in kilns, ovens, furnaces and hearths, for the production of pottery and porcelain, tiles and bricks, iron, copper alloys, bells, glass and dyes for textiles, as well as for malting, vinegar brewing and baking bread. The defences saw action on several occasions during the Civil Wars of the mid-seventeenth century, most famously at the Battle of Worcester in 1651. Worcester continued to develop as the political, social and economic centre of the county through the subsequent centuries. All of these changes have contributed to the way that Worcester appears today, and the city's deep past continues to influence its development.

Eighteen of the twenty digs are in the modern city centre, which has expanded into the surrounding areas, including the medieval suburbs. There are just two outliers, one west of the Severn, the other on the northern edge of Worcester. All twenty (even as far back as the 1830s) were in response to the change and destruction brought by development.

A historic town is a very large and complex archaeological site, comprising remains which are unpredictable in nature, and often deeply buried. Deposits, buried structures and buried features such as ditches form the raw materials of urban archaeology. They are evidence of construction, demolition and rubbish disposal over centuries, accumulated in a confined space; archaeological deposits in Worcester can be between

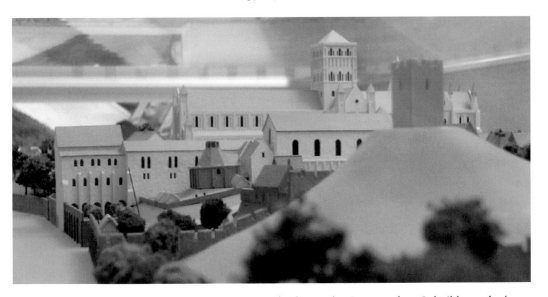

A detailed model of Worcester in 1250 is on display at the Commandery. It builds on the latest archaeological and historical information from Worcester and other medieval towns. This view shows the castle, cathedral and priory buildings, with the Severn visible to the left. The model was made by Hugh Watson for an exhibition to celebrate the millennium. (Reproduced courtesy of Museums Worcestershire)

2 and 6 metres deep. The narrative of an individual site can be complex but also fragmentary, presenting great challenges in interpretation. Only by piecing together the results of many digs will any wider story emerge.

Of course, archaeology is by no means the only way to study a town's past. The framework for the more recent past is set by documentary history, which also provides rich detail of the lives of individual people and households. Careful analysis of nineteenth-century and earlier maps can reveal older street patterns and urban forms, hidden within later townscapes. Buildings very often contain fragments, or more, of much earlier structures. But for the earliest origins of towns, archaeology is usually the only source.

The very first archaeological record in Worcester was made by the ironmaster Andrew Yarranton as far back as the 1650s. While he was quarrying Roman iron slag, at the southern end of Pitchcroft, he found 'one of the hearths of the Roman foot-blasts' (an iron furnace), and 'a pot of Roman coine, to the quantity of a peck'. There may have been 10,000 coins in this hoard, though none are known to survive.

Despite this very early start, the archaeological study of Worcester was slow to develop. During the eighteenth to early twentieth centuries a few finds were recorded by antiquarians (Dig 1). It was not until the late 1950s that Worcester saw its first 'modern' excavation (Dig 2). Archaeological work at that time, where it was possible, was a favour granted by developers, who did not expect to be delayed on site. Individual researchers, including Hugh Russell, Linsdale Richardson and Peter Ewence, had some very limited opportunities. Some small-scale work was organised by David Shearer of Worcester City Museum, and a research group was set up. Philip

Barker and Henry Sandon, in the mid-1960s, were the first archaeologists to mobilise a workforce of volunteers to do more than could be managed by one person working alone (Digs 3 and 4).

By the late 1970s, the government was funding 'rescue' archaeology in towns, and an archaeological profession was emerging. Digs 5 and 6 show how the archaeological response to development was now addressing the destructive impacts of modern construction. Following the traumas of the 1960s, Worcester did not experience major city-centre developments in the late 1970s or early 1980s. As a result, the city's archaeology only came of age with the year-long Deansway excavation of 1988–89 (Dig 8). Policy makers were by then recognising the huge loss of archaeological remains which was occurring. Evaluation – usually trial trenching – and 'mitigation' by excavation or watching brief, paid for by the developer, became an increasingly normal part of development from 1990 onwards. While the 1990s saw relatively little change in Worcester's city centre, in the following decade much of the city was transformed by development as the core expanded outwards and old industries made way for new uses. Digs 11–20 all began between 2000 and 2010. Site work has sometimes continued for ten to fifteen years, even before analysis and reporting.

Barker was a pioneer in modern excavation techniques, recognising that far more information could be yielded by careful observation and recording. He used these insights in his work at Worcester Cathedral (Dig 7). More recently, the cost of modern excavation, including new scientific analytical techniques and the archiving of records so that they can be reanalysed in the future, has focussed efforts on reducing impacts from development, and digging less. This can leave a legacy of archaeological remains, in situ, for potential future investigation with techniques which will certainly be better than those available now.

The most recent dig in the book, the Cathedral Square, was just the latest in a long line of excavations which have contributed to our understanding of Worcester's past development. A story once believed to start with the Romans, has been extended backwards for a further three-quarters of a millennium. Worcester continues to develop. Inevitably this will mean new sites in the city will be the focus of development pressure. There will be further opportunities to investigate, to answer questions and to pose new ones.

The narrative of Worcester's past is increasingly underpinned by evidence, not speculation. Worcester's Historic Environment Record now includes over 2,500 records of excavations and other work (in 1980 fewer than 300 had been catalogued), and over 3,500 archaeological monuments and historic buildings, all linked to mapping in a Geographic Information System.

All this work has involved thousands of individuals – archaeologists, developers, contractors, planning officers, museum curators and many volunteers. This book is a tribute to the skill, dedication and, in some cases, forbearance of all of them.

Dig 1

Worcester Castle's Motte (1833–40s)

'A vast mound of earth has been entirely taken away'

Early paintings and prints show a major feature which is now absent from the city's landscape – the motte of Worcester Castle. This 'keep mound', over 20 metres high, stood to the south of the cathedral for over 750 years, but was completely levelled in

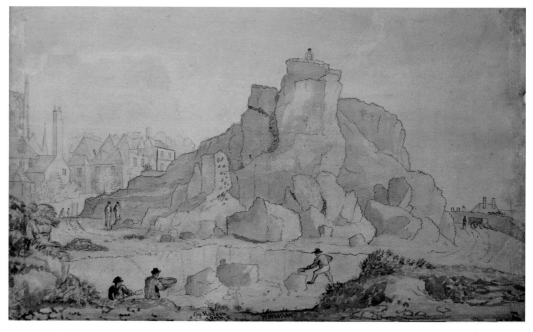

George Hodson's pen and ink drawing of 1826 shows the castle motte in the course of demolition. The mound was eventually completely levelled, and gardens laid out on its site. Towards the left-hand side of the motte, bands of different coloured soil can be seen. (Photograph by Mr Christopher Guy, Worcester Cathedral Archaeologist. Reproduced by permission of the Chapter of Worcester Cathedral (UK))

the early nineteenth century. A new owner of the castle site planned to recoup some of his investment by selling the motte for sand and gravel.

During the work, many archaeological discoveries were made; some of the finds are now in Worcester City Museum. Although this was in no way a modern excavation, contemporary reports describe archaeological observations, as well as the valuable objects. The first report appeared in 1834. Jabez Allies, one of Worcestershire's first historians, expanded this in the first and second editions of his pioneering study of the county's past (1840 and 1852). Not many antiquarian discoveries made during development in the early nineteenth century were recorded to this level of detail.

The motte was huge (estimated at 6,200 cubic metres) and its demolition took several years. Although George Hodson's drawing, dated 1826, shows the work well underway, the earliest reported finds were made in 1833, and objects were still coming to light after 1840. They included a Bronze Age axe (one of several metalwork finds of this period from Worcester), many Roman objects and others from the medieval period and the seventeenth century. Some were found within the mound, including a complete Roman pottery flagon ('made of red earth', probably of the local Severn Valley ware), from about one-third of the way up and 16–18 feet in. It has been suggested that the presence

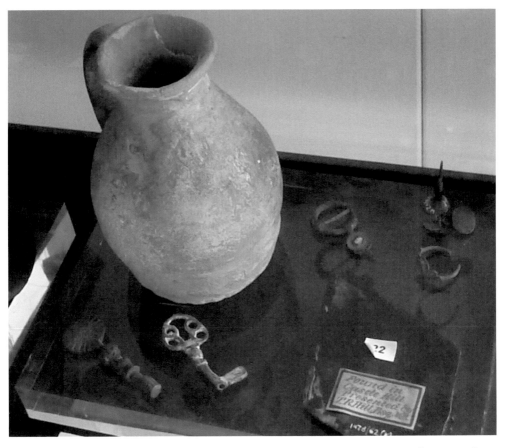

Finds from the castle motte formed an early part of Worcester City Museum's collection and are on display in the Commandery. (Reproduced courtesy of Museums Worcestershire)

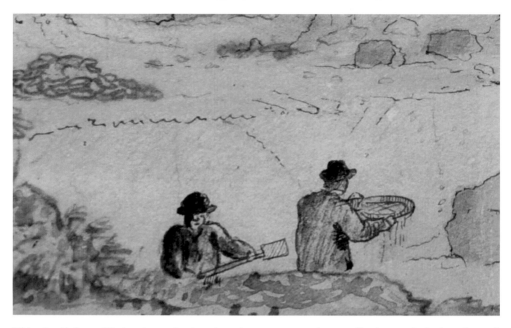

This detail from Hodson's castle drawing shows two workmen, digging and sieving the soil with obvious care. From the finds which were recorded, it is clear that they were instructed to look out for metalwork in particular. (Photograph by Mr Christopher Guy, Worcester Cathedral Archaeologist. Reproduced by permission of the Chapter of Worcester Cathedral (UK))

of the unbroken pot could indicate a Roman burial within a barrow mound, later reused as the core of the motte, but while this is plausible it is now unprovable.

Roman finds included eighty to ninety coins, representing twenty-five emperors from Augustus (27 BC–AD 14) to Gratian (367–383), and, unexpectedly, the much later Byzantine emperor Phocas (602–610). There were nine brooches, two bells and a pair of tweezers. Recorded medieval and later finds were quite scarce, but included coins (some of them Scottish) and Nuremberg jettons (tokens of the fifteenth to seventeenth centuries). No doubt many things that would be painstakingly recovered and analysed by archaeologists today, particularly non-metallic objects, were discarded unnoticed.

Most of the finds came from 'strata of blackish earth, which lay in places both under and also in the hill, but principally under it'. Astutely, Allies thought that these layers were 'the ancient surface of the ground, which had been previously occupied by the Romans'. Also below the motte were a well, 'curiously quoined with stone', and remains of buildings (according to Allies, sandstone foundations). Some of these features may have been of Roman date, while others were presumably associated with the castle. Little can be gleaned about the construction of the motte, though it 'evidently underwent considerable alterations from time to time, according to the modes of warfare of the different ages'.

The descriptions hint tantalisingly at complex interpretations which cannot now be tested. Elsewhere, large and long-lived earthworks have preserved earlier features and occupation surfaces beneath, as probably happened here. However, along with the motte went much of what lay under it. Still, the variety of finds and structures of different periods makes this a fitting place to start a survey of archaeological digs in Worcester.

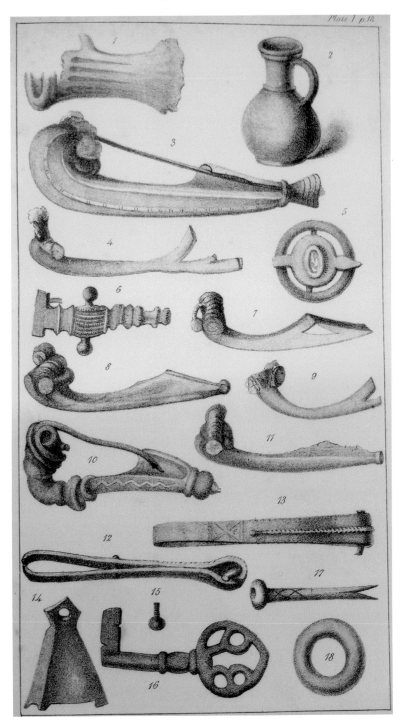

Jabez Allies' drawings of objects found at the castle motte, published in *On the Ancient British, Roman, and Saxon Antiquities and Folk-lore of Worcestershire* in 1852. The object drawings are not to scale: the Roman brooches appear much larger than either the pot or the Bronze Age axe.

Dig 2

Little Fish Street and Warmstry Slip (1957–59)

Worcester's First 'Modern' Excavation

For a century after Allies' discoveries, archaeologists only had very limited opportunities. In the mid-1950s, excavation for massive shop basements along the High Street began to reveal very deep archaeological deposits, with Roman and medieval remains noted at several sites. While thousands of cubic metres of these remains were being ripped out of the city's core, the only archaeological response was a series of watching briefs,

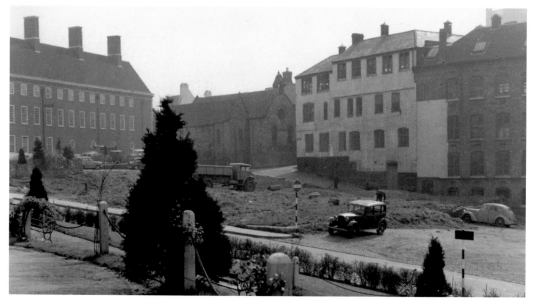

Clearance of the Copenhagen Street area near the riverside was underway in the 1950s, as part of a programme to demolish slums in the city centre. The Little Fish Street site is in the centre of the picture. In the background are the Fire Station, St Alban's Church, and Warmstry House, which became Worcester's first porcelain works in 1751 and was later a glove factory. (Photographer unknown. Reproduced courtesy of Worcester City Council)

mostly by one man, Hugh Russell, without the support of any learned society, museum or university.

All this began to change in March 1957, with what proved to be the first modern archaeological project in the city, sponsored by the Worcestershire Archaeological Society and led by Peter Gelling of the University of Birmingham. Although small in extent, it pointed the way forward to the larger-scale excavations of the later twentieth century. It began with what we would now call an evaluation. Two 15-foot square test trenches were excavated between Little Fish Street, Copenhagen Street and Warmstry Slip, west of Deansway. This was just one of many vacant sites in Worcester, cleared of slum housing and awaiting redevelopment, but it was well chosen.

Siting the trenches was like playing Battleships with the archaeology of the city, but without knowing what types of ships there were, how many, or even if there were any to be found. Urban archaeology in Britain was still in its relative infancy, and had barely reached the Midlands. There can have been no specific expectations of this site, and it was Gelling's good fortune to hit one of the major features of the Roman town. Based on this, he created the beginnings of an archaeological model, elaborated by Barker a decade later, which is still at the core of the story of early Worcester.

In both trenches there were signs of a very large ditch, running roughly east–west. Much had been disturbed by later foundations. Nevertheless, it was clear that this was an important feature and well worth investigating further.

University of Birmingham students are at work here, excavating the long narrow trench at Little Fish Street, September 1957. Working conditions on excavations in the 1950s would certainly not meet modern safety standards! (Michael Meredith. Reproduced courtesy of Anna Meredith)

A team of students returned in September 1957 with the aim of recording the full profile of the ditch. A single long trench, east of the two test trenches, revealed the base of the ditch, allowing Gelling to estimate its full extent at about 18 metres wide and over 4 metres deep. A clay deposit on its southern side was probably part of a rampart, with a late third-century hearth set on top. Brushwood, substantial stakes driven into the ditch fills and a horizontal plank were interpreted as a causeway crossing the ditch. Organic material was clearly well preserved in the lower ditch fills.

Gelling identified the ditch as part of the northern defences of the Roman town, suggesting that it was late Roman and that occupation continued after it had been abandoned.

In 1959, Ewence and Richardson observed the levelling and foundation excavation for the new Technical College buildings, now the Heart of Worcestershire College. Tracking the dark ditch fills across the site, they found a second brushwood causeway across the ditch, and holloways under Copenhagen Street, which may have continued the causeway alignments to the north. They surmised that the ditch had originated as a natural watercourse, one of several which drained the western side of the gravel terrace towards the Severn.

We now know that the Roman defences were still in use in the ninth century. In this area the defence line was probably abandoned when the *burh* defences were extended northwards to enclose the present High Street in the 890s. The brushwood causeways could surely not have been there while the ditch was still an active defence, and most probably they date to the late Anglo-Saxon period. They may even relate to individual properties or plots, laid out in and over the abandoned ditch.

The fully excavated section across the Roman ditch at Little Fish Street, September 1957. The shovel is standing in water in the bottom of the ditch. (Photographer unknown: from a slide held in Worcester City Historic Environment Record. Reproduced courtesy of Worcester City Council)

Dig 3

Lich Street (1965–66)

The Origins of Worcester

During earlier excavations for shop basements, for Marks & Spencer, Woolworths and others, the archaeological response had been minimal. At Lich Street, opportunities were taken to do something more substantial, which left a much greater legacy for Worcester.

Lich Street, so close to the cathedral, was one of the developments which gave rise to the term 'the sack of Worcester', due to the wholesale loss of historic townscape and buildings, to be replaced with a modern shopping precinct. The destruction of archaeological remains here helped to spark the founding of RESCUE, the British Archaeological Trust, which has been a campaigning force for archaeology since 1971. Philip Barker moved to Worcester in 1965, and was shocked by the scale of destruction, and the apparent indifference to it. He helped to found RESCUE, which for many years had its office in Worcester.

An earlier small-scale dig by David Shearer in Newdix Court (a courtyard on the east side of High Street) threw tantalising light on late Iron Age and early Roman occupation, including finds of briquetage (Iron Age salt-boiling vessels from Droitwich), coins of Claudius and 'military' metalwork. Unfortunately, there was no opportunity to investigate this area further, and the small trench is still the largest record of Roman remains from anywhere inside the ramparts. If Roman Worcester had any public or administrative buildings, they would surely have been here or hereabouts.

Most of the Lich Street site was covered only by a watching brief, at first by Henry Sandon, later by Barker. This became more structured and was better recorded than earlier work had been. The archaeologists were also allowed to dig a small area in detail. Barker and a group of dedicated volunteers from the Worcester Archaeological Research Group worked through Christmas 1965.

For the first time in Worcester, archaeology became the collaborative endeavour which will be familiar to anyone who has watched *Time Team* or visited an excavation. As well as the volunteer diggers, Scouts were drafted in to wash finds. Barker's contacts in the University of Birmingham and beyond were invaluable when it came to specialist reports, on subjects as diverse as soil bacteria from a cesspit, medieval leather shoes and some moss found packed into the pointed toe of one of the shoes. In one small pit was a Roman pot, containing bones, which was lifted intact to be excavated in the lab at Southampton University by David Peacock. Initially, the bones were thought to have been the remains of a stew, but Barker's report quoted Peacock's 'increasing sense of dismay' as he realised that the bones

Looking down on the Lich Street site from scaffolding, December 1965 or January 1966. In the foreground, archaeologists are working on the small hand-excavated area. Part of the section through the rampart deposits can be seen next to the 6-foot scales. (Philip Barker. Reproduced courtesy of Peter Barker)

were those of a newborn baby. Neonate burials are not uncommon in Roman towns, often outside cemeteries, though burial in a pot suggests something more formal, perhaps a dedicatory burial.

The excavation was a tiny island in the middle of the development, 'almost miraculously preserved', and was only available because the site was closed for the Christmas holiday. The small triangular area of about 35 square metres represented less than 1 per cent of the whole site. Nevertheless, the sequence of deposits and features recorded in this little area has shaped understanding of Worcester's development from prehistoric to Roman and Anglo-Saxon times. Enhanced with the results of the watching brief, and tested on many other sites across the city, Barker's interpretations have stood the test of time remarkably well.

The feature which dominated the site was a massive Roman ditch, up to 30 metres wide and 6.5 metres deep. To the north-west it became narrower and shallower, as though approaching a gap on the line of the present High Street. The High Street changes direction at this point, as can happen where a road passes through a gateway. The ditch curved across the site for about 150 metres. Conditions did not allow for much recording to either side of the ditch, though there was another large ditch just outside it, to the north-east. This remained mysterious until the City Arcades excavation (Dig 9) over thirty years later.

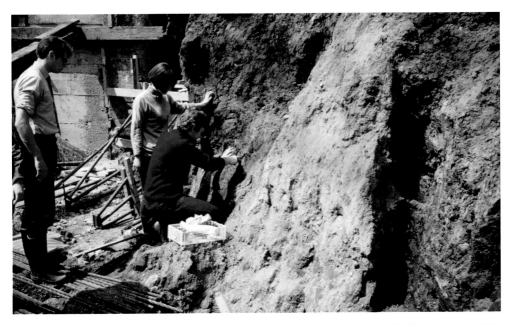

Cleaning a section through the Roman ditch, close to Pump Street, probably summer 1966. (Philip Barker. Reproduced courtesy of Peter Barker)

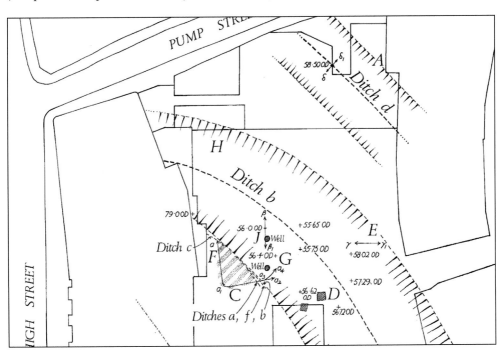

Plan of part of the Lich Street site, showing the massive Roman ditch (Ditch b) and the small (hatched stripes) area of hand excavation. Towards the top right, Ditch d is now identified as being part of the Anglo-Saxon *burh* defences. (Philip Barker. Reproduced courtesy of Peter Barker and Worcestershire Archaeological Society)

Returning to the small excavated area, here the Roman ditch was the latest feature in a long sequence. A group of prehistoric features was preserved below the rampart on the inner edge of the ditch. Barker thought there were two periods of semi-permanent occupation, represented by dark layers, in the late Bronze Age, with a ditch below them which was even earlier. All of these features were sealed by a rampart, whose layers produced no finds, which was associated with an Iron Age ditch. This ditch was cut by a late first-century Roman ditch, which itself was cut by the large ditch, whose fills were dated to the second or third century AD.

Discoveries from the watching brief included a pit containing six well-preserved leather shoes dating to 1350–1450. Other finds were made by the contractors'

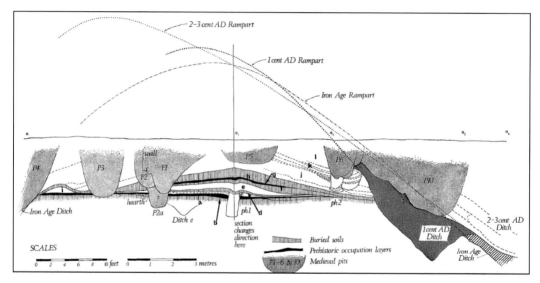

Philip Barker's interpretive section through deposits on the west and south sides of the small excavated area in the centre of the site. Shown here are prehistoric and Roman features, including postholes, occupation deposits, the rampart and several ditches. Broken lines show projections of the height of the rampart at different times. (Philip Barker. Reproduced courtesy of Peter Barker and Worcestershire Archaeological Society)

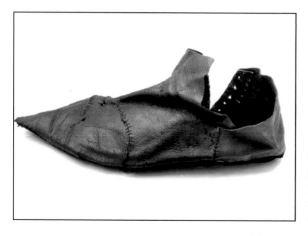

One of the leather shoes found in a medieval pit at Lich Street. This is an adult's side-laced ankle boot; the fashionable sharply pointed toe dates it to about 1450. (Reproduced courtesy of Museums Worcestershire)

workforce, including an early Christian 'chi-rho' device, probably late Roman in date. A more substantial relic from the site was a medieval stone cellar, part of which is now a garden feature at a house near Worcester.

Along with other linear features (ramparts and walls) and extensive fire layers evidencing city-wide conflagrations, ditches like those found here allow archaeologists to establish clear links between sites. Caution is always needed, as these features often had an extremely long lifespan, as was seen at Worcester Castle (Dig 17). Earthen ramparts were the preferred defence throughout most of Worcester's history, until the building of stone city walls in the thirteenth century. With successive defensive lines of Iron Age, Roman, Anglo-Saxon, medieval and post-medieval date, it has been estimated that as much as one-sixth of Worcester's city centre is built over buried ramparts and ditches. A high proportion of these features survives below ground, though remarkably little has been sampled by excavation. On some sites the buried ditches have had major structural implications for later construction.

The Lich Street dig seems a small foundation to build the story of the origins of Worcester on. However, Barker was extraordinarily fortunate in having such an informative block of stratigraphy to work on, and he took his opportunity to tell a completely new version of the story of Worcester.

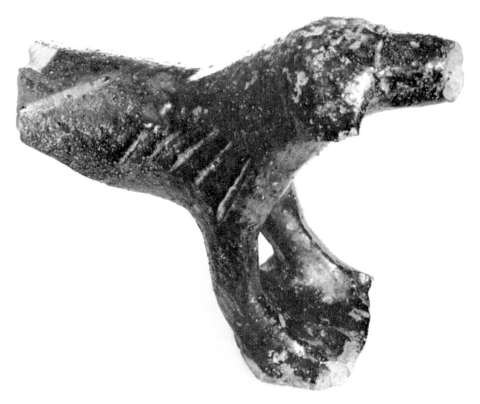

Roof finial representing a hunting dog, found at Lich Street. Decorative ceramic finials like this would have been a common sight on house gables in medieval cities. (Reproduced courtesy of Museums Worcestershire)

Dig 4

Broad Street (1967–68) and Blackfriars (1985–86)

Roman Streets Paved with Iron

The next dig followed shortly after Lich Street, as the north side of Broad Street was being cleared for the Blackfriars Centre. Limited excavation was facilitated by the contractors, but this was mostly a watching brief. Twenty years later, archaeologists had a second opportunity here, in areas further north which had survived the 1960s development. This corner of Worcester, previously occupied by alleyways, tenements and factories, was transformed by the developments, and the precinct (now Friary Walk), bus station and a car park now stand here.

The 1960s work by Barker and Sandon took all the opportunities offered by the site contractors, including detailed recording of three areas, but much of the site plan is blank. In the 1980s, four evaluation trenches (1985) and two larger areas of excavation (1986) evidenced a complexity which was missing from most of the earlier work, but the results are unpublished.

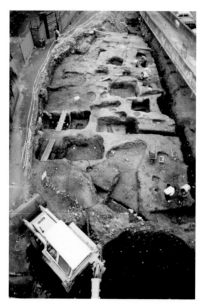

Excavation of pits, foundations and other features at Blackfriars, 1986, looking east towards the buildings of the former Lewis Clarke brewery. This photo was taken from the top of the multi-storey car-park, and one of the car-park ramps can be seen to the right. (Reproduced courtesy of Worcestershire Archive and Archaeology Service)

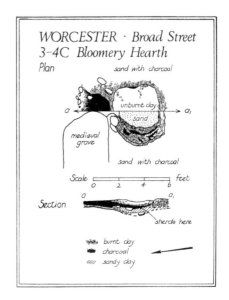

One of Philip Barker's elegantly hand-drawn illustrations from the Broad Street report. This drawing shows the excavated base of one of the iron furnaces, in plan and section. (Philip Barker. Reproduced courtesy of Peter Barker and Worcestershire Archaeological Society)

Hints of prehistoric activity were provided by a hearth and a single potsherd. The Roman remains were much more extensive. Two key elements of the Roman ironworking industry were excavated together for the first time since the 1650s: furnace structures and slag. Four complete furnace bases were found, as well as incomplete ones, forming a small 'iron-smelting factory'. Postholes around them may represent shelters.

Yarranton had been the first to publish a description of Roman iron slag from Worcester. In the seventeenth century, slag heaps could still be seen. Although these have now gone, slag has a big presence in the archaeological record of Roman Worcester. The heavy material, iron-rich due to the inefficiency of Roman smelting, was used to stabilise land, surface yards and in particular to pave roads.

The source of the iron ore is still not known; the Forest of Dean is likely, though there could also have been a local source in the Severn Valley, now worked out. Many factors would have influenced the industry's location; although ore was heavy to transport, charcoal is very fragile, and a local source of wood may have been equally important.

The slag-surfaced road found at Broad Street was the first to be excavated in Worcester. The base layer and earlier road surfaces were of pebbles and sand, with a ditch to one side. The later surfaces were of slag, with shallow wheel ruts. This sequence has proved to be typical of Roman roads in Worcester, suggesting that slag was unavailable for surfacing in the first to early second centuries AD. The slag road was about 10 metres wide (the earlier surfaces were narrower) and could be traced crossing the site for about 50 metres, though just 5 metres was excavated in detail. In 1985, the road was seen again, 100 metres north of Broad Street, while in 1990 a slag road on the same alignment was seen 130 metres further north again, on a site by the railway.

The road and nearby workshop gave the first hint of a settlement pattern in Roman Worcester. Several Roman pits were excavated, one containing a small hoard of seven coins of the early AD 270s. One of two stone-built Roman wells contained a large pottery assemblage and two small pieces of painted wall plaster.

A 5-metre-wide ditch, at right angles to the road and cut across the top of one of the wells, could have been a late-Roman property division, though an Anglo-Saxon date is

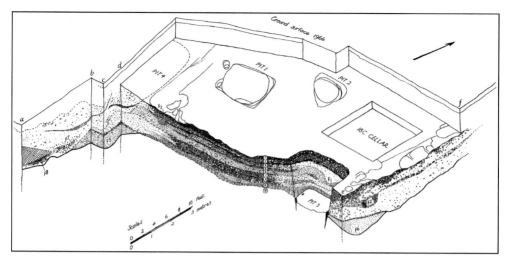

Axonometric (measured perspective) projection drawing of part of the Roman road at Broad Street. The postholes cut into its edge may be from roadside buildings. On the front edge of the road, a section through successive surfaces of pebbles, gravel and slag can be seen. (Philip Barker. Reproduced courtesy of Peter Barker and Worcestershire Archaeological Society)

also possible. Further north, the road could still have been in use in the tenth or eleventh century, when a building containing a bread oven and another oven was built next to it.

Although inside the city wall, this area of medieval Worcester seems to have been quite unpopulated until the arrival of the Dominican friars (Blackfriars) in 1347; there was no sign that earlier occupation had been displaced to make way for the friary. The massive sandstone walls of the Blackfriars are evidence of buildings 'of cathedral quality', though it is uncertain whether the excavated remains are those of the friary church, cloister or other buildings. Recording conditions were very difficult, and did not allow the tracing of robber trenches in the many cases where walls had been completely removed. Several graves from the Blackfriars cemetery were found, while a solidly-built stone-lined well may also have been associated. The friary was dissolved in 1538. Commonly, as here, friaries were rapidly demolished and the materials used in new buildings. The site became gardens, and only in the eighteenth and nineteenth centuries was it densely built up with housing courts and factories.

The city wall defined the northern edge of the Blackfriars site, forming a revetment and overlooking the open land outside the city. Although the defences saw little military action in medieval times, events during the Civil War made up for this. The city's defences had been strengthened at the start of the war, though incompletely. During the two-month Parliamentary siege in 1646, an area of higher ground here was chosen by the defenders to create a strongpoint or 'blind' within the walls. Henry Townshend, in his diary of the siege, described a defence of poles, rafters and hurdles, packed with earth and horse dung, added inside the 'weak old wall'. Excavation in 1986 found a ditch which was probably part of this defence. This would literally have been the 'last ditch' if the besiegers had breached the city walls.

A late seventeenth- or early eighteenth-century pottery assemblage from a well may have been related to one of the local inns. The mugs, bowls and chamber pots illustrate a more peaceful and convivial side of the city's life at this time.

Dig 5

City Walls Road (1967–76)

Revealing Worcester's Medieval Defences

The construction of City Walls Road led to archaeological projects spanning nearly a decade. Initially work was undertaken by volunteers of the Worcester Archaeological Research Group. Later they were supplemented (and finally replaced) by professional archaeological teams.

Projects included recording of standing city-wall fabric (some of which was later demolished), excavation of areas at the foot of the wall and part of the Friar's Gate, and watching briefs, covering an area about 750 metres in length. Most of the records were made in a concentrated campaign of work in 1973. Reports were published in *Medieval Worcester* in 1980, alongside a documentary history of the defences by Clive Beardsmore.

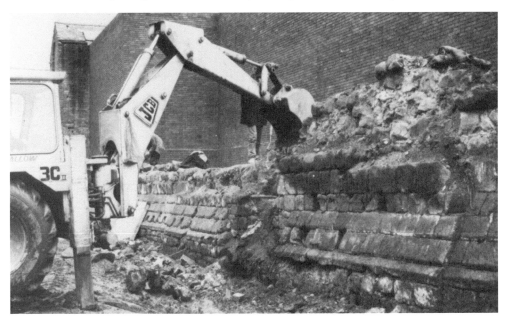

Not all of the newly revealed wall could be saved from destruction. This photo from 1976 shows the demolition of a well-preserved stretch of the wall, including the remains of tower T1, just south of Friar's Gate, to make way for City Walls Road. (P. J. Clarke, West Midlands Rescue Archaeology Committee. Reproduced courtesy of Worcestershire Archaeological Society)

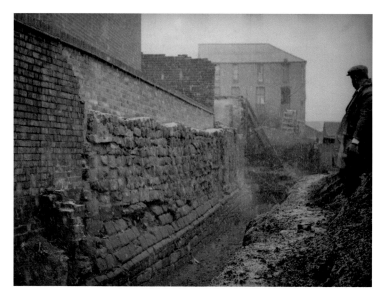

A workman contemplates the remains of the city wall, newly exposed in 1973 during clearance for road construction. This part of the wall, south of St Martin's Gate, was preserved and is on public view. (Photographer unknown: from a print held in Worcester City Historic Environment Record. Reproduced courtesy of Worcester City Council)

In two and a half centuries since the abandonment of the defences (towards 1700), the area became densely built up. The City Corporation leased and later sold the infilled ditch area. Much of the land was bought by adjacent landowners inside the wall, who often added it to their gardens, levelling the wall where needed; Broad's map of 1768 shows a string of gazebos along the wall. Later, as occupation in the city centre intensified, houses and factories were built over the ditch and against the wall.

The new inner ring road was part of the post-war Minoprio and Spencely plan for Worcester and enabled the pedestrianisation of the High Street. Creating it required the clearance of a 25-metre-wide swathe along most of its length. At the northern end of the road the zone of demolition extended to nearly 100 metres, including several whole streets.

A complete record was made of the newly exposed outer wall face. Excavation of the wall was possible in places, as well as some excavation both in front of and behind the wall. There was little opportunity to explore the ditch, apart from its inner edge, though one machine-excavated section was rapidly recorded. It proved to be quite different from what has been found on the north side of the city. Up to 10 metres wide, it was flat-bottomed and up to 4.5 metres deep from modern ground level.

Sue Hirst's watching brief at Talbot Street South allowed the construction of the wall to be tied in to earlier deposits. Roman remains here included a 7-metre-wide channel, perhaps natural, and postholes from a structure. Roman occupation may have been abandoned because of flooding from the Frog Brook. The wall was predated by two ramparts. One of these may have been associated with an earlier defensive alignment. The other was immediately within the wall line and was probably part of the initial medieval defensive layout, later replaced by the masonry wall.

Documentary evidence tells us that construction of the wall took place over two centuries or more. Tolls were collected to build, and later repair, the walls, starting in 1224. The last record of these 'murage' payments was in 1439, during the Wars of the Roses. No evidence has been found to allow relative dating of the various wall sections. Archaeological recording has revealed that the wall construction followed a

broadly predictable pattern. A shallow and roughly-faced stone foundation supported the ashlar-faced wall base. The foundations and plinth were typically about 2 metres thick; above this a batter of between three and five chamfered courses reduced the wall's thickness to about 1.2 metres for its upper courses. Here, ashlar masonry faced a rubble core; the inside wall face was far less well finished.

The topmost parts of the walls, which were presumably crenellated, have not survived. At one point there was evidence of a wall walk, and there is a very small survival of a second set of chamfered courses near the top of the wall, close to a small tower by St Martin's Gate. Not all of the visible stonework is medieval. Some of the upper parts show changes in build style and probably date to the Civil War, when the defences were repaired.

The Battle of Worcester map is an important resource for understanding the defences in the Civil War, including the addition of bastions and defensive lines linking Fort Royal to the city walls. Archaeology has revealed that features on the map are often shown schematically. Sometimes, however, the map and the archaeological record do support each other; for instance, in the identification of a tower (known to the archaeologists as T1) at the point where the Fort Royal earthwork joined the walls. A series of holes cut into the stonework here may have been for a framework to carry the Civil War defence

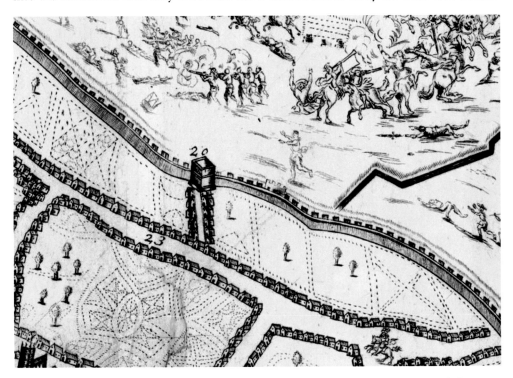

Enlarged detail from *An exact ground-plot of ye City of Worcester as it stood fortifyd, 3 Sept. 1651* (Robert Vaughan, published 1662). The map shows in a schematic way the city walls and the additional defences added in the Civil War. This extract shows the Blockhouse – the rebuilt Friar's Gate, very different in appearance to the surviving medieval gates, an adjacent tower (probably T1) and part of the earthwork line linking the walls with Fort Royal. (British Museum: public domain)

across the medieval ditch. Just to the north of here was the Friar's Gate. This was a small and presumably weakly defended medieval postern gate, built for the Greyfriars, and was rebuilt as a strongpoint called the Blockhouse. Excavation revealed remains of the gate and bridge abutment.

At its southern end City Walls Road turns south-west and crosses the wall line. Where the clearance crossed five house plots on the north side of Sidbury, limited recording was possible. One very significant find was a fifteenth-century barrel, which had been set into a pit and used as a latrine. This was particularly interesting for the peaty layers inside it, containing cloth fragments, beetles, seeds, grains, fruit stones and the eggs of parasites (whipworm and roundworm).

Building the City Walls Road has left a significant legacy in the form of several hundred metres of visible wall, which had previously not been publicly accessible. This requires regular cleaning and maintenance. Sadly, the presence of the busy dual carriageway means that the wall is not appreciated by most visitors to Worcester. Recording of the defences continues, with over 150 archaeological records made since the 1970s.

 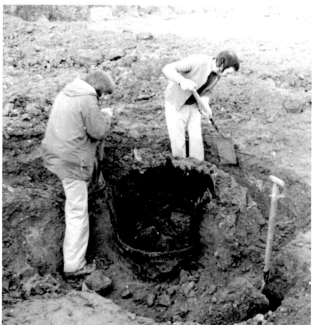

Above left: The stone foundations in the foreground are for a bridge across the city ditch. Just behind are foundations of Friar's Gate. This gatehouse was rebuilt in the 1640s as the Blockhouse, part of the Civil War defences. Photographed during excavations in 1976. (Reproduced courtesy of Phil Shearman)

Above right: Clive Beardsmore and Garston Phillips of Worcester City Museum preparing for the lifting of the fifteenth-century wooden barrel during clearance for City Walls Road. The barrel had been set into the ground in the back plot of a house on Sidbury, to be used as a latrine. Preserved seeds and fruit pips from the barrel included apple, blackberry, wild strawberry, sloe, grape, fig and fennel, indicators of medieval diet. (Photographer unknown: image from Worcester City museum collection, reproduced courtesy of Museums Worcestershire)

Dig 6

Sidbury and the Vue Cinema Site (1976–77 and 1997–2000)

A Roman Water Supply and Roadside Suburb

The site known to archaeologists as Sidbury is now in Friar Street, following late twentieth-century street reorganisation. The Vue Cinema stands here, and that development was the occasion for a second archaeological campaign, from 1997. Although this covered a large area, it was very fragmented. In contrast, one corner of this site saw the first large excavation in Worcester, in 1976–77; most of the results described here are from this work. This was 'rescue' work, in advance of an unbuilt road scheme; the site then remained undeveloped for twenty years.

The scale of the 1970s work had led to high expectations; as often happens, the excavation answered some questions, but many more were posed. In 1976 Martin Carver's University of Birmingham team dug the medieval and early post-medieval periods within three former tenement plots, handing over in 1977 to John Sawle of the County Council unit, who excavated the Roman levels. The later periods were published in *Medieval Worcester* (1980); the reporting was sketchy in places, and no doubt more could be gleaned from the archive records. Publication of the Roman phases waited for fifteen years but was much more thorough.

Analysis of the Roman period identified seven phases. The first and fourth centuries were fairly thinly represented; this is not unusual for Worcester. The most intensive activity was in the mid-Roman period, between the early second and late third centuries AD. The key feature of the site was a sequence of surfaces, which in the later phases clearly formed a road, leading south-east from the centre of town.

In the first century AD, a single ditch crossed the site, close to Friar Street. It was backfilled in the late first century and an extensive pebble surface was later laid over the top.

The second century saw construction of a series of buildings and structures, with postholes, and stakeholes for fences. One structure was 15 metres long, defined by a series of parallel beamslots, set about 3 metres apart. Between were joists, and between the joists, more closely spaced timbers. This structure could have been a building, or

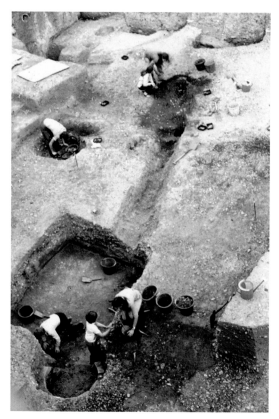

Left: The Sidbury excavation in 1977: excavation of Roman features including the ditch and postholes of a later second-century boundary, cut into an early second-century pebble surface. The large rectilinear pit in the foreground is late medieval or post-medieval in date. (Reproduced courtesy of Worcestershire Archive and Archaeology Service)

Below: Site layout in the second century, as revealed by excavation in 1977, including the structure of a boardwalk or timber floor. (Reproduced courtesy of Worcestershire Archive and Archaeology Service and Worcestershire Archaeological Society)

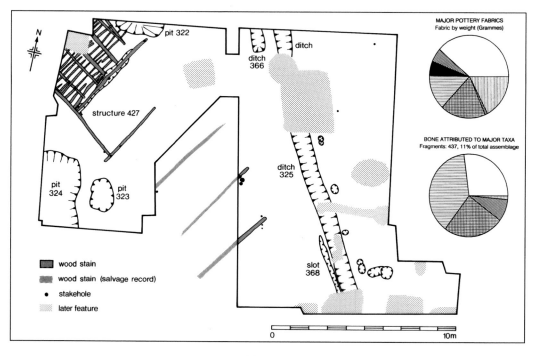

more probably a boardwalk; the surrounding area seems to have been damp. Close by was a pit containing the lining of a clay hearth, domestic pottery, butchered animal bones and four early Roman coins.

In the late second to late third centuries, the site was dominated by the road. Initially, this was surfaced with pebbles. Associated finds included brooches and a military belt fitting. In the early third century large quantities of sand and gravel were dumped to level the site, and a new surface of pebbles set in marl was laid down. Later that century a very substantial slag surface, up to 0.7 metres thick and 5 metres wide, was added. Wheel ruts in the surface were from wheels set about 2 metres apart.

By the late third century, wooden water pipes had been laid along the road, in a shallow gully cut into the surface of a pebble and slag road. Only the iron junction collars survived, but a sequence of gullies suggest the maintenance of a public water supply over several decades. Both the source of the water (probably inside the defences) and its destination (perhaps a standpipe) lay outside the site. Public water supplies were rare in Roman Britain, and are otherwise only known from major towns. Worcester is unlikely to have had a comprehensive water supply network; a dozen road sections have been excavated since, but nothing similar has been seen.

The Roman finds assemblage was surprisingly large for what was a relatively small site. The depth of relatively undisturbed deposits may account for this. There were several metalwork objects usually associated with military sites, including fragments of armour, belt fittings and a carrying handle for a helmet. Other finds indicating a Romanised lifestyle included a pottery lamp from the Rhineland, decorated with a scene of two lovers, and a yellow glass intaglio depicting the head of the goddess Roma.

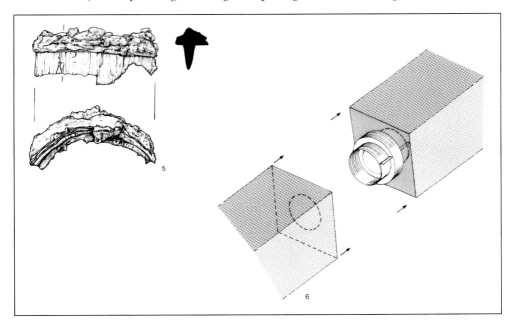

Drawing of an iron pipe collar from a Roman water supply, in use in the late third century AD, with a reconstruction showing how this sort of collar would have been used to join the wooden pipes. (Reproduced courtesy of Worcestershire Archive and Archaeology Service and Worcestershire Archaeological Society)

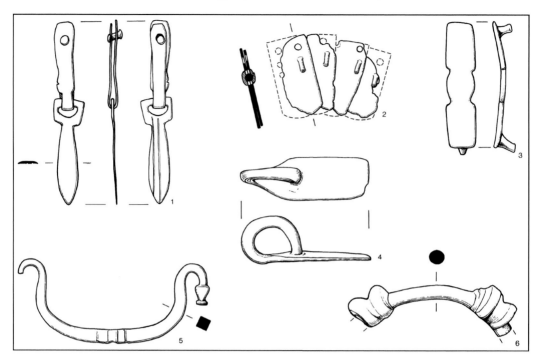

Drawings of military metalwork found at Sidbury, including armour fragments and a carrying handle from a helmet. (Reproduced courtesy of Worcestershire Archive and Archaeology Service and Worcestershire Archaeological Society)

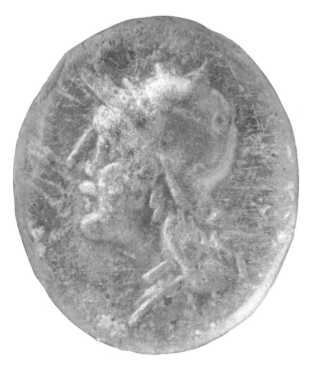

Roman glass intaglio, carved with the helmeted head of the goddess Roma, who personified the Roman state. This would have been mounted on a finger ring and may have been used to seal documents. Although found in a late second-century context, the intaglio was probably made more than 100 years earlier. (Image from Worcester City museum collection, reproduced courtesy of Museums Worcestershire)

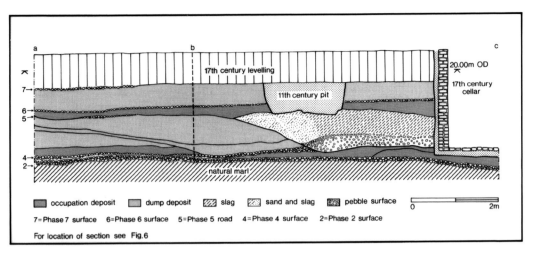

a simplified section through the archaeological deposits at Sidbury. The bulk of the sequence here dates to the Roman period. Road and other surfaces are interleaved with dump layers, some of them quite substantial. Medieval deposits here were almost entirely removed in the seventeenth century, probably to create ramparts during the Civil War. (Reproduced courtesy of Worcestershire Archive and Archaeology Service and Worcestershire Archaeological Society)

Ground levels across the site were raised by 1.6 metres in the three centuries between the laying of the earliest and latest Roman surfaces. This may well have been a planned response to flooding, by the local stream (the Frog Brook) or by water backing up from the Severn, half a kilometre downstream. Flooding may well have caused the abandonment of the area in the fourth century, and it was probably not reoccupied for 500 years.

Eight pits of ninth–eleventh-century date were the first evidence of Anglo-Saxon domestic activity to be found in Worcester. Finds of daub and nails suggested that buildings were timber-framed and nailed together. The three house plots which survived until recently were probably first laid out at this time, within a suburb known as *Suthbyrig*.

In the medieval period, the area took on a distinctly industrial character. The middle plot was occupied in the twelfth–fourteenth centuries by a worker in bone and antler. Finds from a twelfth-century pit included sawn offcuts and fragments decorated with incised concentric circles and openwork. The northern plot had evidence of bronzeworking later in the period. More substantial industrial remains characterised the fifteenth to early seventeenth centuries, with small hearths for bronzeworking in the middle tenement, the flue of a tile kiln in the northern one and another kiln, possibly used for making moulds, in the southern tenement. There is evidence of some specialisation in the bronze industry, with larger objects (cauldrons and perhaps bells) being made in the northern tenement, and finely decorated objects such as buckles in the southern tenement.

Further north on the site there were a number of clues indicating a high-status medieval stone building. This was an aisled hall, with stone-founded walls, a tiled floor, surviving in the form of the mortar floor-base with tile impressions, and a stone column, probably supporting a vault. Floor tiles were found loose in the demolition rubble; these

included plain glazed tiles and decorated tiles (eighteen different patterns found here can be matched at the cathedral). Glazed ridge tiles from the roof were also found. In Worcester these larger stone buildings were typically set well back from the frontage, and would have provided a private oasis from the noise of the street.

On the eastern edge of the site the medieval defences were recorded, amplifying the discoveries from City Walls Road. At half a dozen locations on this side of the city, a rampart has been found inside the wall, but the relationship between the two features is disputed. Given the expense of building a stone wall, the expected sequence would start with a rampart and ditch, with the wall added later. Here, however, the rampart (which survived to a width of 7 metres and height of 0.95 metres) seems to have been dumped against the wall, suggesting that they were contemporary. If they were built together, it is likely that this was one of the earliest lengths of stone walling.

Post-medieval quarrying near the wall was probably to win material for the refurbishment of the defences during the Civil War, when a new rampart was added on top of the medieval one. A scatter of postholes could have been for a defensive structure. Defence against artillery needed earthwork defences as well as walls to absorb the impact of cannonballs.

The potential of the deep deposits in the city centre was realised for the first time at Sidbury, and the results threw new light on the Roman, Anglo-Saxon and medieval periods, setting an agenda for many of the digs which followed.

Dig 7

Worcester Cathedral (1981–91)

The Burial of a Pilgrim

After over 1,300 years, Worcester Cathedral remains central to the life of the city. When the Cathedral of St Peter was founded in 680 it was literally central, in the very middle of the Iron Age and Roman earthwork (already over 1,000 years old), which was then to form the first Anglo-Saxon defence. About half of the area enclosed by the earthwork is still within the cathedral precinct. Worcester was founded during a great age of Mercian cathedral foundation, alongside Hereford and Lichfield. Bishop Oswald refounded the cathedral as a monastic institution in the 960s. Many of the surviving medieval buildings are monastic in origin. Oswald built a second cathedral church, dedicated to St Mary. Archaeologists have searched for traces of both early cathedrals, but not yet found them. Bishop Wulfstan started to rebuild after the Norman Conquest, and the crypt survives from his cathedral. Other Norman work, mainly in the transepts, is later in date, and most of the rest of the cathedral was rebuilt in the thirteenth and fourteenth centuries.

Worcester Cathedral was one of the first to appoint an archaeological consultant, and has had a full-time archaeologist since the 1980s. The volume of restoration and other work has made the last forty years very busy. Much of the day-to-day work of the cathedral archaeologist consists of detailed recording of the standing fabric, watching the re-excavation of trenches for drainage and other service repairs, or excavating new trenches by hand. There have been particular concentrations of larger-scale work around the crossing tower and crypt, and around the chapter house and other monastic buildings to the south.

In the early 1980s a structural survey of the tower showed that it was in danger of collapse. Detailed archaeologically led investigations of all four tower piers followed, in 1981–87. The tower is 62 metres high and weighs around 4,200 tons, but it transpired that it rests on stone foundations which are just 1.4 to 1.75 metres deep, and scarcely wider than the piers themselves. Each pier sits on a very slightly wider base of 'banded hoggin' of unknown depth – rammed sand and gravel laid in horizontal layers, which provides a solid footing for the massive structure. The excavation showed that each of these bases had been dug and filled individually. Although on the face of it the medieval foundations seem quite inadequate for such a massive structure, the investigations

WCSETP 87

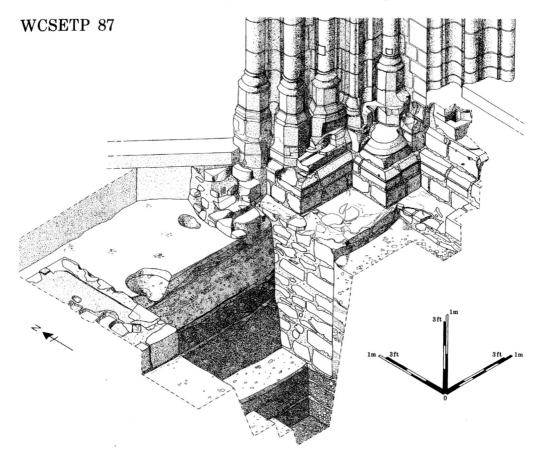

Axonometric drawing of the south-east tower pier, excavated in 1987. The pier itself is fourteenth century in date, while the foundation is mostly Norman. A small section excavated through some of the 'banded hoggin' can be seen at the bottom of the trench. (Christopher Guy; reproduced by permission of the Chapter of Worcester Cathedral (UK), and courtesy of Worcestershire Archaeological Society)

showed that they were solid and that the structural problems which had been found were all above ground.

Around the same time, a series of archaeological excavations was undertaken in the Norman crypt. The first of these, at the west end (1982–83) was associated with the tower investigations. Later work (1984, 1986–87, 1991) investigated both the north and south sides of the crypt, including a larger excavation at the south-east corner to allow the formation of a new staircase to access the crypt. Wulfstan's crypt, with its aisles, apse and a forest of small pillars, was built in the 1080s. There was an eastern ambulatory, with polygonal chapels projecting beyond it. Excavations showed that Roman iron slag had been used in bedding layers. Pieces of Anglo-Saxon sculpture were found in pillar foundations, and much of the stonework may have been reused from the Anglo-Saxon cathedrals. The polygonal chapels and the ambulatory were infilled in the thirteenth century when the eastern part of the cathedral was rebuilt.

The presence of a large building here for a millennium or more has given rise to exceptional preservation conditions. Archaeologists are used to finding remains which have been preserved by waterlogging, but here it is extreme and stable dryness which has preserved organic remains in localised sealed deposits. The 'Worcester pilgrim' burial, found in 1986, was the most remarkable of several burials found during the excavations. The elderly man buried here was wearing leather boots, and fragments of his woollen twill clothes also survived. Alongside him were a wooden staff, 1.55 metres long and painted purple. Its base was protected by a double-pronged iron spike, and there were traces of horn at the top. Another find was a cockle shell with a pierced hole. Research has suggested that the man buried here was Robert Sutton, who died in 1454. He was a dyer, and a parishioner of St Andrew's, Worcester. He paid for the fine carved vaulting bosses in the tower there, which along with the later spire (the Glover's Needle) has survived the demolition of the rest of the church. Sutton went on pilgrimage to Santiago de Compostela in 1423. Although the scallop shell is the better-known symbol of St James, the cockle may have been a substitute. The pilgrim has been reburied, while his boots and staff are on display in the cathedral.

There is no doubt that the cathedral church and its surrounding precinct still hold exceptional archaeological potential. A trench dug on College Green in 2019–20 produced remains including a remarkable series of building foundations, some of them dated to the Anglo-Saxon period. Analysis of these findings is now underway.

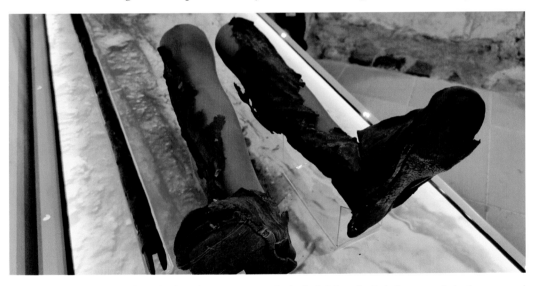

The pilgrim's burial as displayed in Worcester Cathedral. The pilgrim's boots and the bottom end of his staff with its double iron spike can be seen. (Photograph by James Prior; reproduced by permission of the Chapter of Worcester Cathedral (UK))

Dig 8

The Deansway Excavation Project (1988–89)

From Roman Small Town to Medieval City

Now known to most people as Crowngate (a shopping precinct which links High Street and Broad Street), this site is still called Deansway by archaeologists. This remains the largest excavation in Worcester. About 50 archaeologists were on site for nearly 18 months, and 30,000 people visited the excavations. From 4 main sites, covering 1,900 square metres, they recovered a mass of finds, including 140,000 potsherds, 115,000 fragments of animal bone and well over 2 tonnes of iron slag. The published reports, by 38 main contributors, run to well over 1,000 pages.

Four areas of car park had been scheduled as ancient monuments, based on findings in trial trenches in 1985. The scheduling was to be crucial in negotiations between the

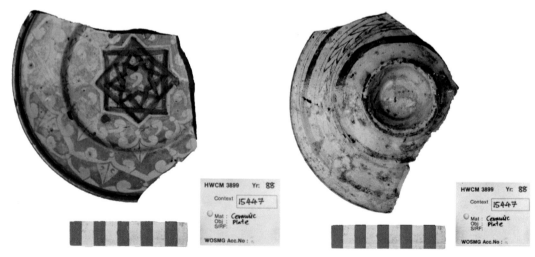

Front and back views of a highly decorated late fourteenth-century lustreware dish from Valencia, Spain. This is the earliest of several Valencian pots found at Deansway. Pottery imported from central Italy, Saintonge (France), Seville, Merida and Malaga in Spain, the Low Countries and the Rhineland was also found here. (Reproduced courtesy of Worcestershire Archive and Archaeology Service)

archaeologists and developers, while the results from the trenches allowed the scale of the work ahead to be estimated.

The excavation focussed on areas of proposed basements (currently House of Fraser and Primark), the last of the great shop basements to be built in Worcester in the second half of the twentieth century. Every development-related archaeological project involves a degree of compromise. Here, Powick Lane and other streets remained in use during the excavation, and were only covered by later watching briefs. These would no doubt have held remains of equal importance and interest. Indeed, the earlier periods were probably better preserved below the medieval streets, free from the intensive pit digging seen elsewhere.

Deansway produced important results for every main period of Worcester's past. Traces of prehistoric origins included a roundhouse and an Iron Age horse burial. Six silver coins of the Dobunni tribe were found, probably minted just before the Roman conquest, and more than have ever been found elsewhere in Worcester.

Occupation in the Roman period was complex and long-lived. Because of the extent of the site, it was possible to see patterning and to conjecture how the layout of Roman features influenced developments in later periods. The site lies between two north–south roads, one followed by the High Street, the other further west, seen at Broad Street (Dig 4) and also at the Heart of Worcestershire College site in the 1960s.

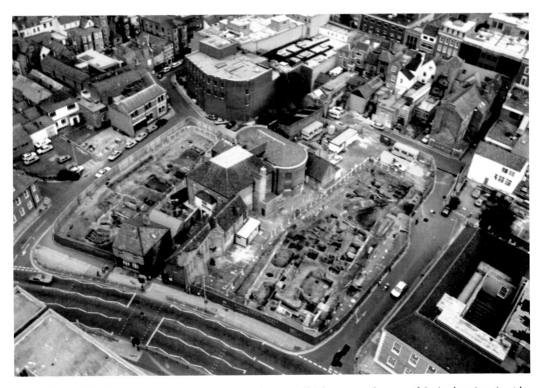

View of the Deansway excavations, taken from scaffolding near the top of St Andrew's spire (the Glover's Needle), which was then under repair. Sites 1 and 2 are either side of the Countess of Huntingdon's Chapel (now Huntingdon Hall). The High Street is visible at the top of the picture. (Reproduced courtesy of Worcestershire Archive and Archaeology Service)

During the mid- to later first century AD there was low-intensity agricultural and industrial activity. This was associated, however, with pottery and brooches of types which archaeologists link with the Roman military. No structural evidence has yet been found, but these finds hint that the elusive fort, assumed to have been part of the early foundation of Worcester, could have been nearby.

After a gap in the years around AD 100, the site was reoccupied, this time more intensively. The two main roads were linked by three evenly spaced parallel lanes, providing a structured layout. Although the remains were fragmented by later pit-digging, there were timber buildings, one of them with stone foundations. There was also much more evidence for ironworking, including burnt patches, probably marking the sites of furnaces; the above-ground structures had been destroyed. Crucibles and fragments of glass debris attest to glassworking, and there may also have been bronzeworking.

Later in the Roman period, settlement intensity declined, and the area returned to a mainly agricultural use. Some ironworking may have continued, while evidence for

Plan of Roman lanes and boundary ditches in the mid-second to late-fourth century. The three parallel lanes linked two major roads, one on the High Street alignment, the other 150–200 metres further west. The line of the northernmost of the lanes is thought to have been followed by the rampart defining the north side of the Anglo-Saxon *burh*, over 500 years later. (Reproduced courtesy of Worcestershire Archive and Archaeology Service)

tanning may relate to the establishment of stockyards. Towards the north-west of the site, a cemetery was established, enclosed by a ditch and dated to AD 300–400. Despite the small number of burials, this is the largest cemetery known from Roman Worcester. The fourteen graves were mostly aligned north–south. Nine of the deceased had been buried in hobnailed boots, and three had been decapitated with the head placed by the feet. Beheading is certainly an unusual burial rite, but was frequent enough in late Roman Britain not to have been 'special', though the meaning is unknown.

Roman remains were sealed below a layer of 'dark earth' which is thought to relate to a long period of grazing and manuring, from the fifth to the ninth centuries. The only recognisable feature from this period was a clay oven, perhaps for making bread, dated by archaeomagnetism to the seventh to eighth centuries.

Just south of Broad Street, a short section of an earthwork rampart was found, fronted by a large ditch. For the first time a feature was found which could be associated with the establishment of the Anglo-Saxon *burh* at Worcester. The front of the rampart was revetted in limestone, perhaps supported by a timber frame, and probably topped with a palisade. These structural methods are seen at other *burhs* in the Midlands, such as Tamworth. *Burhs* were defended strongpoints, mostly urban. They were established by King Alfred in Wessex, and later by his daughter Æthelflaed ('Lady of the Mercians') and her husband Æthelred, in Mercia, in their campaigns against the Danes, who had occupied eastern and central England. A document places the foundation of the Worcester *burh* between AD 889 and 899. Intriguingly, the rampart alignment followed one of the Roman lanes.

Contemporary with the defence was a scattering of rectangular buildings, using a variety of construction techniques. One was built of planks, driven into the ground. A second was post-built and had a central hearth, while a third had turf walls. The plank building was then replaced by two further buildings, one post-built, while the other had a wooden baseplate into which vertical staves would have been slotted – a method common in Scandinavia and also used in London.

Occupation became much denser again in the medieval period. In the thirteenth century, Broad Street was later laid out just outside the *burh* defences, with houses and plots overlying the ditch. A number of substantial stone or stone-founded buildings were discovered, suggesting relatively high status. One of these had a vaulted undercroft with

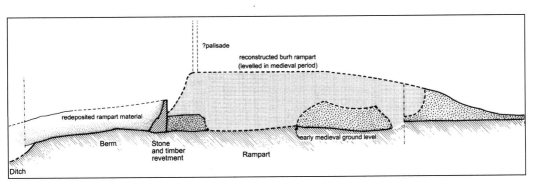

Section through the Anglo-Saxon *burh* rampart close to Broad Street (Deansway site 5). Along with the edge of the ditch, small parts of the rampart survived, preserving evidence for a stone and timber revetment to its outer face. (Reproduced courtesy of Worcestershire Archive and Archaeology Service)

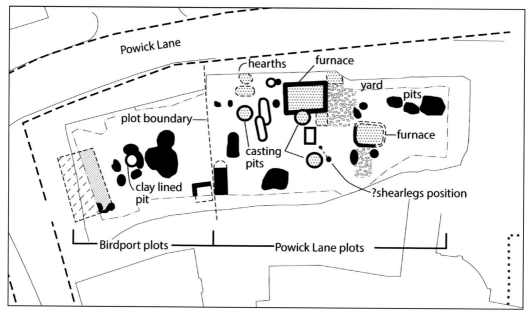

Plan of the fourteenth-century bronze foundry at Powick Lane (Deansway site 1). Excavated features included hearth bases, the foundations of substantial furnace structures and casting pits for large objects such as bells. (Reproduced courtesy of Worcestershire Archive and Archaeology Service)

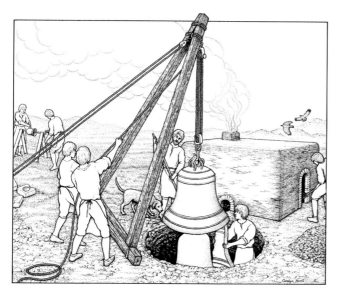

Reconstruction drawing of work at the foundry in Powick Lane (Deansway site 1). A shearlegs (two-legged lifting frame) is being used to raise a newly-made bell from the casting pit. The excavation recorded postholes which may have been associated with shearlegs, next to a casting pit, though much of the structure would have left no below-ground trace. (Reproduced courtesy of Worcestershire Archive and Archaeology Service)

Norman columns. There were also industries, including a bronze-founding workshop. Bells were cast here, as well as cauldrons, skillets and candlesticks. Sheet metal and wire were used to make smaller objects, such as book fittings and pins.

Among the most interesting medieval finds were some inscribed slates, dated to the fourteenth century. One had what appears to be a fragmentary prayer, while another

included a written list, part of a rent roll. A third, with sketches and writing, is illustrated here.

The Deansway excavation transformed understanding of Worcester's development. A concurrent research project by Nigel Baker and Richard Holt, funded by the Leverhulme Trust, on the development of medieval Worcester and Gloucester provided essential context. This was a thorough melding of archaeology, documentary history and urban geography. Baker and Holt worked backwards from the nineteenth-century topography, mapped in great detail by the Ordnance Survey, to interpret the medieval layout of the city, and then further backwards, with the help of the findings from Deansway and other excavations, to propose a sequence of major replanning events from Roman to medieval. The deeper and wider understanding provided by the survey still informs archaeological work in the city, while Worcester has become an exemplar of the post-Roman re-establishment of towns in England. The extent and detail of the report, meanwhile, has meant that

Incised script and sketches of a stag's head with antlers, a tree and a three-petalled flower scratched on to a slate, described as 'the remnants of a medieval waste paper basket'. The style of the Latin writing dates this to the fourteenth century. (Reproduced courtesy of Worcestershire Archive and Archaeology Service)

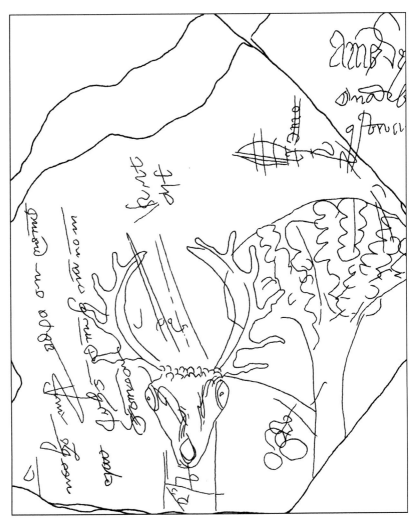

students worldwide have been able to use the site as a case study and to base new research projects on it.

The project was academically and archaeologically transformative, but it also had an important effect in the way archaeology was seen in the city. The excavation, and a programme of public events scheduled alongside it, captured the public imagination and created a level of support which has persisted. Shortly after the excavation, Worcester City Council appointed its first archaeological officer, Dominic Perring, and published a planning policy for archaeology, anticipating national policy. Perring was succeeded at the council by Charles Mundy, director of the Deansway excavation.

Hal Dalwood, deputy director of the excavation, describes the site to a group of visitors including the Mayor of Worcester, Bernard Neil. (Reproduced courtesy of Worcestershire Archive and Archaeology Service)

Dig 9

City Arcade (1997–98)

Hospitality from Roman Times to the Eighteenth Century

After Deansway, there was a lengthy lull in archaeological activity, with no major excavations for nearly a decade. The City Arcade development, opposite the Guildhall, brought this to an end in 1997.

City Arcade is one of several places in Worcester where the coaching inns of the seventeenth and eighteenth centuries, with front and rear entrances, created links between streets, later taken up by shopping arcades. The King's Head had a High Street frontage and stabling on The Shambles. Since 1800 the site has been redeveloped four times, for a market hall (1804, rebuilt in 1851), a concrete shopping arcade (the first City Arcade, 1956) and the present building.

Most of the excavations described so far were on developments which were designed with little thought for preservation of archaeological remains. Here, the tide was (belatedly) turning. Planning policy for archaeology (known to a generation of archaeologists as PPG16) enjoined the preservation of archaeological remains in situ, and there was a growing awareness of the risk which unexpected discoveries of archaeological remains could cause to a development. The foundation design here ensured that a good proportion of the archaeological remains would not be destroyed. However, large concrete pads were used, rather than the slender piles which are more common nowadays. Excavation for these extended into the natural gravel, so it is only between the pads that deposits survive.

Ground conditions had proved a problem here in the past. The first market hall became unstable, while the rebuilt hall suffered such severe subsidence that new foundations were needed in little over a decade, when they had to dig down 13–14 feet to find good ground. Reasons for this were to become clear.

The 1950s arcade had basements at both ends, though otherwise its foundations were not deep. During construction, Hugh Russell collected a number of finds, though (implausibly) he thought they were all unstratified. Close to the High Street was a medieval vaulted undercroft.

An evaluation was arranged while the old building was still standing. Five small trenches were dug, including some in the basements. The remains found were significant enough to justify a full archaeological excavation before construction went ahead. Only a limited time window was available for excavation following demolition, and some of the most important discoveries came during a later watching brief on the excavation of foundations.

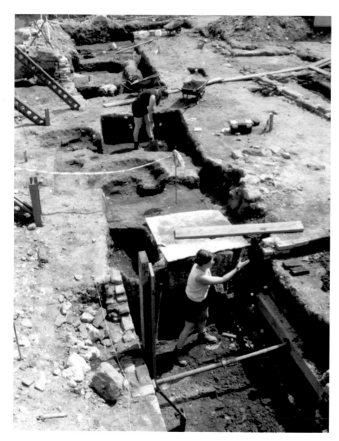

The site at City Arcade under excavation, looking eastwards towards The Shambles. Deeper trenches have been dug on the sites of the intended foundations. (Reproduced courtesy of Worcestershire Archive and Archaeology Service and Worcestershire Archaeological Society)

A remarkable discovery in the evaluation was a substantial Roman building. Its remains were immediately below the 1950s reinforced concrete basement floor near the High Street. As they would not be affected by the development, they were not investigated further. From the very limited investigation, the Roman building was given a broad date bracket (mid-first to mid-third centuries AD). Robber trenches indicated where there had been stone walls and foundations. A fired-clay floor had later been replaced by a substantial mortar one. Finds indicating the nature of the building included roof tile, daub and painted wall plaster, while pottery included Samian and amphora. The building was sited just outside the town defences and alongside the High Street and the probable line of the road to Droitwich; this would be a typical location for a *mansio* or official roadside stopping place – a Roman motel.

Near The Shambles were postholes of a timber building, associated with a clay surface and the remains of two or three shaft furnaces or their tapping pits. Analysis of slag showed that both smelting and smithing were carried out here.

Roman features in the centre of the site, including an infant burial in the top of a pit (perhaps a stillbirth), were cut away by a large ditch, aligned north–south. This was at least 14 metres wide and 2 metres deep. Fills tipping down its western (presumed inner) side suggested that there had been a rampart, partly stone-faced. Dating of the ditch was difficult, with only Roman pottery in the lower fills, and twelfth-century pottery in the very top. No Anglo-Saxon material was found in the ditch itself.

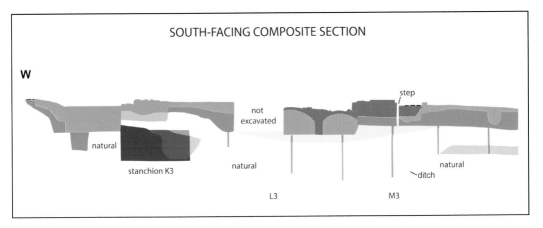

SOUTH-FACING COMPOSITE SECTION

W

step

not
excavated

natural

stanchion K3

natural

natural

ditch

L3

M3

Simplified section across the eastern part of the City Arcade site. The darker colours are excavated features, while the paler fills have been interpreted from a series of boreholes. The Anglo-Saxon *burh* ditch is shown in blue; relatively little of the ditch fills were seen. (Reproduced courtesy of Worcestershire Archive and Archaeology Service)

Nevertheless, the location of the ditch fits well with the model of middle Anglo-Saxon growth of Worcester first worked out during the Deansway excavation. The existing defences further south would no doubt have been refurbished in the mid-ninth century to counter the Danish threat. At the end of the century, Æthelflaed and Æthelred agreed the establishment of a new *burh* with Worcester's church authorities. This extended the town to the north, and was the origin of the High Street as a commercial force. The ditch and its accompanying stone-faced rampart, as found at Deansway (Dig 8), provided a formidable defence. The ditch excavated here probably aligned with a ditch found on the south side of Pump Street (Dig 3), which joined the earlier defences.

It isn't known whether The Shambles existed in 900. However, not too long afterwards (tenth or eleventh centuries), industry in the form of iron smithing hearths was underway just east of the ditch, so the presence of a street there is likely. This can perhaps be linked with the industrial and craft activities at Sidbury (Dig 6). A small group of pottery of this period included imports from Stafford, Stamford and St Neots.

Medieval remains on this site proved less interpretable, but included the foundations of substantial sandstone buildings, one with a clay floor, and a stone-flagged yard. Pits and other features appear to be associated with industry, while finds of moulds and crucible fragments may point to bronze-casting.

The site holds significant interest from more recent times. The origins of the King's Head go back to the mid-seventeenth century. Cesspits in the back yard of the inn had been used to dispose of broken goods, many of them redolent of an eighteenth-century tavern. Among the finds were 'onion' wine bottles, wine-glass fragments, tygs (mugs with three or more handles) and clay tobacco pipes. A group of stoneware tankards imported from Germany included one with a royal cypher.

During the eighteenth century the King's Head became one of Worcester's main places of entertainment, with art exhibitions, displays of exotic wild animals and, from at least 1717, a theatre. The building which housed the theatre seems to have been

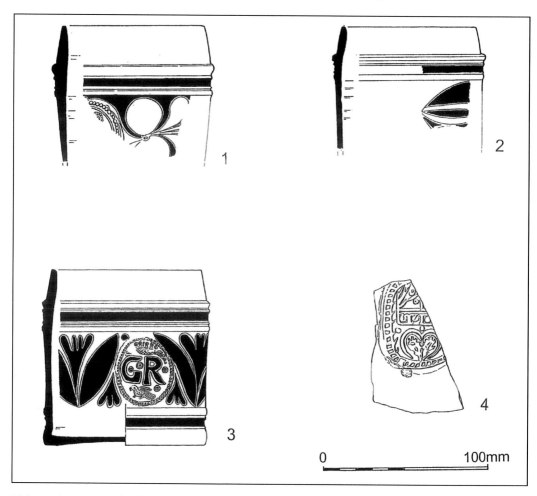

Eighteenth-century salt-glazed stoneware tankards made at Westerwald in Germany. The broken tankards were found in one of the cesspits associated with the King's Head, and had no doubt been used there. 'GR' (*Georgius Rex*) refers to one of the Hanoverian kings, probably George II. (Reproduced courtesy of Worcestershire Archive and Archaeology Service and Worcestershire Archaeological Society)

more of a barn than a grand assembly room. Maps show it set at an angle to other buildings, towards The Shambles. It was here in 1767 that the twelve-year-old Sarah Kemble made what was probably her second stage appearance, as Princess Elizabeth in Havard's *King Charles I*. As Mrs Siddons, she was to become the most famous actress of her age. Archaeologists unearthed remains of a humble structure 230 years later. A foundation of driven timber piles and a low wall of stone and brick probably supported a timber-framed building, about 6 metres wide and perhaps no more than 15 metres long. It had originated in the seventeenth century and was rebuilt in the eighteenth century. Could this have been the scene of the young Sarah Siddons' early stage triumph?

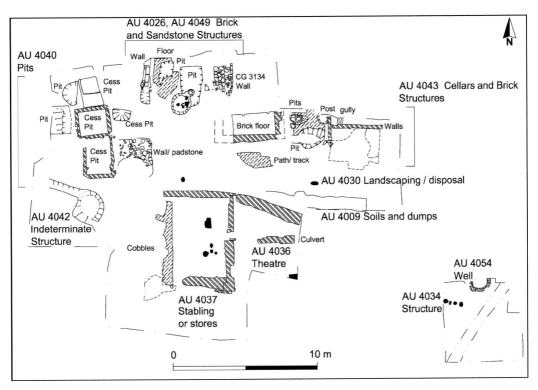

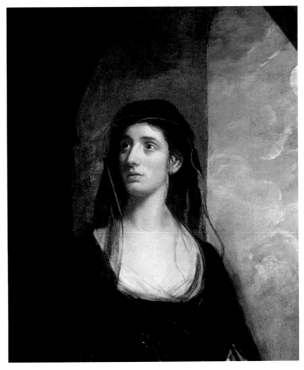

Above: Plan of post-medieval features at City Arcade. These include foundations of a building, probably the barn where theatre performances took place (lower middle), and cesspits containing tavern assemblages (top left). (Reproduced courtesy of Worcestershire Archive and Archaeology Service and Worcestershire Archaeological Society)

Right: Detail of a painting of Sarah Siddons by Thomas Beach, *c*. 1790. Sarah's father, Roger Kemble, founded a theatrical dynasty. She was born in Brecon and grew up in Worcester. In this portrait she is not playing a theatrical role, but is in the character of the goddess Melancholy, from the poem 'Il Penseroso' by Milton. (National Library of Wales: public domain)

Dig 10

Sites in Castle Street (1998–2000)

At the Northern Edge of Roman Worcester

For several years a crumbling post-war office block on the north side of Castle Street was home to the County Archaeological Service. Staff unwittingly parked their cars over remains of Roman Worcester, which only emerged when the site was redeveloped at the turn of the millennium. Linked police station and Magistrates' Court buildings now occupy the area.

Evaluation trenching, excavation and watching briefs at the police station in 1998–2000 were undertaken by Worcestershire Archaeology. Roman features were found, concentrated in one corner of the site. Here a ditch extended eastwards into the Magistrates' Court site, and turned south at its western end, enclosing land to the south. The ditch dated to the second century AD and was replaced by a boundary (or perhaps a building) defined by postholes. Inside the enclosure, excavation between two nineteenth-century cellars at the south-eastern limit of the site recorded a pit, over 1.6 metres deep. The pit contained a large quantity of Roman pottery, several fragmentary horse skulls and building materials such as roof and flue tiles. This probably represented redeposited rubbish rather than a single event.

The excavation at the neighbouring Magistrates' Court (2000), by Archaeological Investigations Ltd, was much larger. It revealed two quite different zones. In nearly all phases the south-western corner of the site contained concentrated industrial and other features. Across the remainder of the site were scattered buildings, both circular and rectangular, but otherwise this area was characterised by extensive stone surfaces.

There were significant challenges. The site as a whole was much more complex than expected. Very sadly, the excavation director, Darren Vyce, was diagnosed with an aggressive form of cancer just after the excavation finished, and died within weeks. Other staff took up the challenge of analysis and reporting, and the report was eventually published in 2020.

Here again, Roman occupation started at the beginning of the second century, with a continuation of the ditch seen at the police station, which extended for at least 60 metres. Postholes indicated the site of a circular building inside the enclosure, and fragmentary foundations of buildings, associated with hearths and ovens, formed a workshop, with evidence for iron smithing.

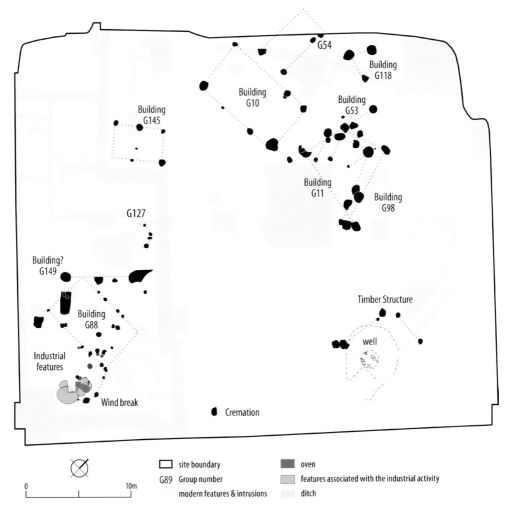

Magistrates' Court site. Site plan covering the period between 125 and 240 AD. The postholes represent a number of buildings, some of which were rectilinear and aligned on a south-west to north-east axis. Other features included a stone-lined well and an isolated cremation burial in a pot. (Reproduced courtesy of BAR Publishing and Headland Archaeology)

In the early to mid-second century the site layout changed, with the ditch infilled and at least five rectilinear timber buildings erected. The largest of these was 9 metres long, with three bays and possibly a porch. The buildings were again associated with industrial ovens and hearths.

In the third century the buildings were cleared, the site levelled and gravel and stone surfaces laid down. This may not have been an open space: subtle patterning in the stones, and in the finds which lay on the surface, suggest that there could have been a number of rectilinear buildings, constructed either with timber sill-beams set on the surface, or possibly of cob. The south-western corner continued in industrial use, with ovens and also troughs, perhaps timber-lined, and clay-lined pits to hold water. Hammerscale, retrieved from samples using a magnet, is the clearest evidence that this

 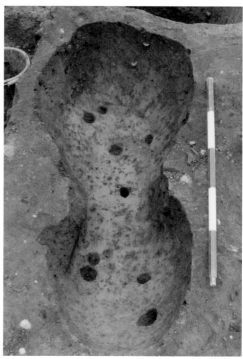

Above left and above right: Magistrates' Court site. A 'figure of eight' oven. On the left the oven has been partly excavated, with surviving fragments of its clay and stone lining still in place. On the right is the fully excavated oven. The stakeholes are evidence of wattle supports for the superstructure. (Reproduced courtesy of BAR Publishing and Headland Archaeology)

was a smithy. This area of Worcester seems to have been abandoned early in the fourth century.

Although Roman Worcester is well known to archaeologists for its iron industry, on most sites this consists of smelting in shaft furnaces. Smithing is much less well represented in Worcester itself, though small-scale activity is frequent on rural sites nearby. The smithy found at the Magistrates' Court is the most substantial site associated with this activity in Worcester. Iron bars and a billet were found here, and it is quite likely that iron was worked here into a form which could be made into tools by more specialist smiths elsewhere.

Over half a tonne of Roman pottery was found. The presence of several waster sherds from failed firings and a kiln bar hint that greyware pottery was being made in the area, possibly on the site itself. A fragment of a sideboard, carved in sandstone, is an unusually Romanised find for Worcester. As much of the site seems to have been used as a midden, with rubbish brought in for dumping, it is unlikely to indicate the lifestyle of people living here.

When these sites were excavated they were thought to mark the northernmost extent of Roman Worcester, giving way to a scattering of less 'urban' finds. There are signs of a possible villa in Britannia Square, 200 metres north of Castle Street; painted wall plaster and *tesserae* from pavements and mosaic floors have been found there. More recent discoveries have shown that Roman ironworking extended at least a kilometre further north, to the banks of the Barbourne Brook.

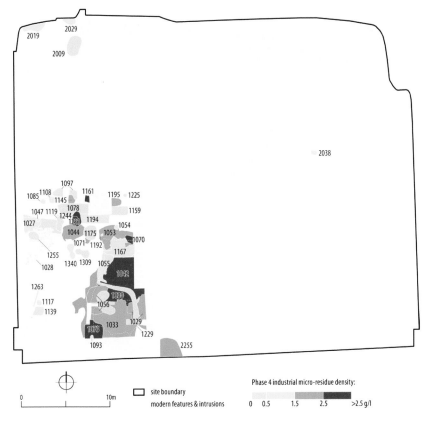

Magistrates' Court site. Plan of the Roman workshop area showing the distribution of ironworking 'micro-residues' found in samples from features and surfaces. The highest densities (in red) are located in and around smithing hearths. This phase is dated to between AD 250 and 320. (Reproduced courtesy of BAR Publishing and Headland Archaeology)

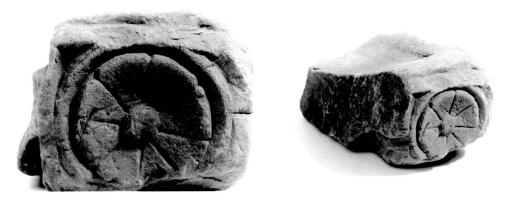

Part of a stone side table, carved with a rosette on the front and with a recessed top. Similar stone furniture has been found at Roman villa sites in the Cotswolds, where limestone is used. The side table found at the Magistrates' Court site is the only known sandstone example. (Reproduced courtesy of BAR Publishing and Headland Archaeology)

Dig 11

Park & Ride (Perdiswell, 2000)

A Bronze Age Place of Assembly?

On the northern edge of Worcester, Perdiswell was until 2000 an area where not much was known, archaeologically. When a site came up for development as a park and ride car park, there was little expectation that any significant finds would be made. However, the excavation marked the emergence of the Barbourne Brook Valley as an area of archaeological interest, and prompted the reconsideration of some earlier finds. Not far from Perdiswell are the nineteenth-century findspot of an early Roman neck ring or torc and a field name (Barrow Cop) suggestive of a burial mound. Parchmarks in the dry summer of 1976 revealed the plan of a Roman triple-ditched enclosure next to the brook. More recently, another enclosure has been found nearby, this time prehistoric, while further upstream, evaluation has found a small Bronze Age enclosure and late prehistoric timber trackways in the marshy upper reaches of the brook. Downstream, excavation on the site of the former Worcester City football ground revealed waste from Roman ironworking.

The site was evaluated by geophysics and trial trenches. The only feature found was the curving ditch of what seemed to be a round barrow. It was decided that it should be excavated before the car park was built.

An excavated section of the Bronze Age enclosure ditch, clearly showing the palisade slot in its base. (Reproduced courtesy of Worcestershire Archive and Archaeology Service)

Full excavation provided new interpretations. It emerged that the site was not a barrow, and that the 'ditch' was probably not an open ditch but a trench for a palisade of close-set posts, in a deep slot in its base. No post impressions were found, however. The trench depth of 1.5 metres suggests that posts would have stood to 4 or 4.5 metres above ground (a ratio of 1:3). The excavators suggested that the posts had been deliberately removed when the site went out of use, and that the trench may then have persisted as a shallow open ditch. Some tree-throw holes along its line could indicate that it continued to be marked above ground by a hedge or other vegetation.

The feature was roughly circular, enclosing an area 27 metres in diameter, and with a single 3.25-metre-wide entrance facing south-east. The trench had a variable profile, but there were consistent characteristics. In particular, the steep-sided slot at the base, cut into the loose gravel, showed very little evidence of weathering, and could not have been left open for long.

The site had been levelled, presumably by ploughing, and any bank there was had gone. Some tip lines of pebbles within the fills may show where bank material had weathered into the trench after the posts had been removed. Also missing were the upper fills and edges of the trench, along with any small internal features which may have been present.

There were very few finds. Flint implements or flint-working waste, so characteristic of the Bronze Age, were absent. Seventy-nine potsherds, found scattered within the fills of the eastern side of the ditch, were probably all from a single pot, in the Biconical Urn tradition of the earlier Middle Bronze Age. One rim-sherd was decorated with a wavy line and fingertip impressions, and other sherds also had fingertip impressions. There were two pierced holes in the pot. One had been made during manufacture, perhaps so that it could be hung over a fire; the outside was sooted so the pot had probably been used for cooking. A second hole had been made later and may show that the pot was valuable enough to have been worth repairing. Detailed thin-section analysis showed that the rock tempering used in making the pot came from the Malvern Hills.

Radiocarbon dates from charcoal in the bottom of the trench were from the mid-second millennium BC, with a spread between 1530 and 1190 BC, confirming the site as middle Bronze Age.

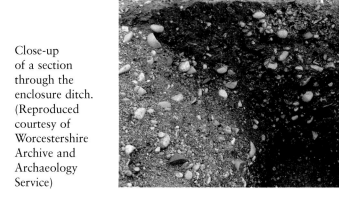

Close-up of a section through the enclosure ditch. (Reproduced courtesy of Worcestershire Archive and Archaeology Service)

The Perdiswell enclosure is hard to classify; similar sites of this date are extremely rare anywhere in Britain, even more so in the Midlands. It is best (though blandly) described as a ringwork, but in the Bronze Age these sites were very variable in size, form and function. In its immediate area the enclosure seems to have been on its own, on flat land about 100 metres away from the Barbourne Brook. The excavated structure and finds give little clue as to what was going on here. The absence of signs of occupation may hint that this was a place of assembly. The palisade would have formed a solid barrier, rendering the interior invisible from the outside, but for what purposes? Certainly, it predates any known occupation in the centre of Worcester by nearly 1,000 years.

After the discovery, the short-lived car park was redesigned to reflect the layout of the enclosure, incidentally gaining some extra spaces as a result. The site has now been redeveloped for a school.

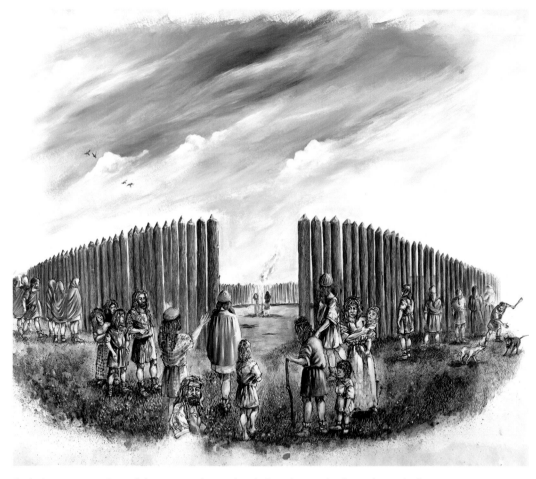

Artist's reconstruction of the Bronze Age palisaded enclosure, looking through the entrance into the interior. There was no evidence of a gate structure. (Steve Rigby. Reproduced courtesy of Worcestershire Archive and Archaeology Service)

Dig 12

Archaeology at the Royal Worcester Porcelain Factory (2004–18)

Where Industry and Fine Art Combined

The Royal Worcester Porcelain works extended for over half a kilometre, from Sidbury southwards alongside the Worcester and Birmingham Canal to the Severn. It overlapped the city wall at the northern end, where a large proportion of the work has taken place, but was otherwise outside the medieval city. Archaeological work has included input from four archaeological consultants, four historic building consultants, four archaeological units and a geophysics team, working for three developers. Reporting has been much more fragmented than usual.

The factory site, in use from *c*. 1790 to 2008, has been completely transformed by development, symbolised by the change in street names – in the nineteenth century the

The Royal Worcester Porcelain Works viewed from the west: a print from *Great Industries of Great Britain, Volume I, c*. 1880. Many of the buildings shown in this view are still standing, though all of the kilns have been demolished.

main street through the works went by the name of Frog Lane, but it is now called Princes Drive. Many of the nineteenth-century factory buildings have been adapted for residential use. Where new buildings have been added, their foundations have been carefully placed to minimise disturbance of archaeological remains, including those of the medieval city wall, the Church of St Peter and its burial ground. This has limited the extent of recording. Nevertheless, there are traces of all periods from Roman onwards.

This part of Worcester has been shaped by its location in the floodplain of the Frog Brook, which limited the early growth of the city. To the north-west, the Iron Age earthwork which forms the city's core lay on the higher ground between the Frog Brook and the Severn, on land which was both dry and more easily defensible. Later, the brook was engineered, firstly to become part of the wet ditch of the medieval defences, and then from 1815 part of the canal.

Roman remains have been found in several places at Royal Worcester, but have not been investigated on a large scale. The northern end of the site overlaps with the southern limits of Roman Worcester, and the signs of occupation near the later city wall soon peter out.

This area is usually understood to have been outside the Anglo-Saxon town. However, layers of redeposited red marl found here and on a watching brief close by in Severn Street could be remains of a rampart. The documented Anglo-Saxon district of Suthbyrig (Sidbury) may therefore have been defended by an earthwork in the late ninth or early tenth centuries, on a line just inside that of the medieval defences. The alignments of King Street and St Peter's Street may relate to this. Further south, around Portland Street, there is evidence of an iron industry, associated with ditches dated by pottery to the eleventh or twelfth centuries.

The northern part of the site is traversed by the medieval defences for nearly 200 metres, from the castle in the west to a corner close to the canal, and then northwards towards Sidbury Gate. The city wall has been seen in five places, adding to the understanding gained elsewhere on its circuit. The ditch is deep, with only its upper fills seen.

Just within the angle of the city wall was the Church of St Peter the Great, founded in the tenth century. The church was rebuilt in the late medieval period and again in 1838, and finally demolished in 1976. When St Peter's gained a burial ground in the late seventeenth century, this extended across the city ditch. The crypt of the nineteenth-century church has been partly excavated and was found to incorporate walls and foundations from the medieval structure. Many burials were excavated to make way for the redevelopment of this area. Related finds included part of the memorial slab to Robert Chamberlain, founder of the Severn Street porcelain works.

The medieval defences were refurbished during the Civil War, with earthen ramparts added both inside and outside the city wall. An external line of defence was also provided, strengthening the south side of the city and linking to Fort Royal, just to the east. The Battle of Worcester map shows this line incorporating projecting bastions, reflected on site in the zig-zag alignments of excavated ditch sections.

Remarkably little remained below ground relating to over 200 years of porcelain manufacture on the site. This was generally a tidy industry. Waste material (kiln furniture and distorted or heat-shattered pottery) was taken away and sold as hardcore: farm tracks all around Worcester made good use of it. Underground tanks for slip and other materials were found. However, there was also a distinct lack of foundations, especially of kilns. Two kiln sites were excavated, but the structures had been completely grubbed out. An unusual exception to the lack of waster material was a small pit containing hundreds of Firestone spark plugs for tanks; during the Second World War

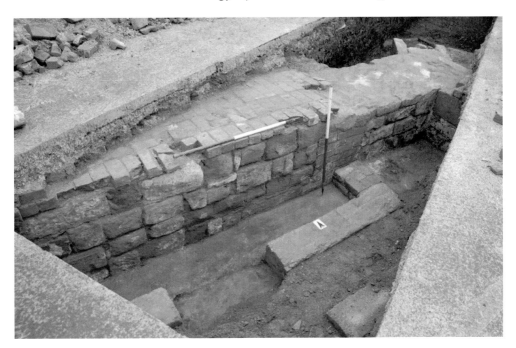

This trench revealed part of the north wall and interior of the Victorian Church of St Peter. Although the church itself was built of brick, stone-built parts of the demolished medieval church were used as foundations. (Reproduced courtesy of Worcestershire Archive and Archaeology Service)

Graffiti with initials IH and the date 1823, on a buttress at the east end of St Peter's Church, excavated in 2013. The medieval Church of St Peter the Great was demolished in 1838, just fifteen years after the graffiti was carved. (Reproduced courtesy of Worcestershire Archive and Archaeology Service)

the workforce was called on to provide their skills for specialised war production. A fire watcher's post from this time survives atop one of the buildings.

Fifteen years of archaeological fieldwork at Royal Worcester have now been completed. While the work to date has not thrown much light on porcelain manufacture, one of the few sites remaining to be developed here does include the core of Robert Chamberlain's works of the late eighteenth century. Otherwise, the interest has been primarily in the earlier periods, and the development has been designed to leave most of the remains in situ.

Dig 13

Newport Street (2003–05)

Worcester's Cloth-working Quarter

Newport Street was once part of the commercial core of Worcester, at the entrance to the city from the west and Wales, and also one of its key industrial areas. With the opening of John Gwynn's new bridge in 1780, approached by Bridge Street, Newport Street was changed almost overnight from an important commercial thoroughfare into an unloved backwater. Demolition of the medieval bridge at its western end followed swiftly, and the area's subsequent decline was relentless. The backplots between Newport Street and its back lane, Dolday, became heavily built up with tenements in narrow courts, as elsewhere in the city centre. These courts became some of the most notorious slums in the city, described in an 1849 report to the Board of Health as 'very crowded, very damp, dirty and unhealthy'; the occupants of sixteen tenements had to share one privy with an open cesspool. By the beginning of the twentieth century, Newport Street's fate had been settled, and just before the First World War slum clearance began. This proceeded by fits and starts, with land turned over to other uses including a bus station and car parks. By the close of the twentieth century, very

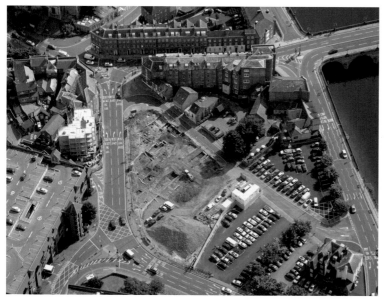

An aerial view of the excavation at Newport Street, looking south. Newport Street, which runs diagonally across the centre of the photograph, led to Worcester's medieval bridge across the Severn (lower right), replaced in the late eighteenth century by the present bridge (upper right). (Reproduced courtesy of Mike Glyde)

few buildings remained, and in 2003 development of a large apartment block was proposed.

A watching brief on boreholes noted deep archaeological deposits including beds of iron slag. Evaluation trenching followed in 2004; this found that the remains were very complex and survived immediately below the car park. Before the development went ahead, an excavation was required. This covered the whole footprint of the development, between Newport Street, Dolday and All Saints Road. 3,000 square metres were excavated, making this the most extensive excavation in Worcester before the Hive. Archaeologists from Cotswold Archaeology and Worcestershire Archaeology combined to dig the site between August and December 2005. Only the upper levels were dug, with the remainder still there below the building, though punctured by the pile foundations. Just two small areas were excavated in full so that the whole sequence of occupation could be understood.

The earliest excavated feature was a Roman road, which ran parallel with and just to the north of Newport Street. A width of 5 metres was seen, with a gentle camber, and it was probably a lot wider. It led to the riverside, where there would have been quays and a river crossing – a ford or ferry, or perhaps a bridge, on the same site as the medieval bridge. The road had a slag and cobble surface, with some wheel ruts, and layers of alluvium intervening between surfaces suggested that there had been frequent flooding and repair. It was unlike other Roman roads so far found in Worcester, in that it had later origins (late second to early third century) and no initial gravel surfacing. This suggests an increased use of the floodplain as the town developed. The road went out of use by around 300, its disuse marked by large sherds of fourth-century pottery lying on its last surface.

Cut through the road was a late Anglo-Saxon well, probably infilled in the eleventh century. This was seen in a small excavated area and it is not known whether there was extensive occupation at that time. The area went out of use during the eleventh and twelfth centuries and half a metre of flood silt was deposited. Towards the end of the twelfth century a concerted effort was made to reclaim this part of the floodplain, by dumping soil to raise the ground levels by over 2 metres. Around 1250 the plots along Newport Street were being laid out and buildings erected. These plots persisted into the twentieth century, in some cases into the early twenty-first.

Roman road, cut by an early medieval pit. The excavators dug a slot through the road to reveal details of its construction. This road was probably first built in the late second or early third century AD, later than most of the roads found in Worcester, and the surfaces were made up of slag and cobbles. Note the preserved wooden stakes (bottom left). (Reproduced courtesy of Cotswold Archaeology and Worcestershire Archive and Archaeology Service)

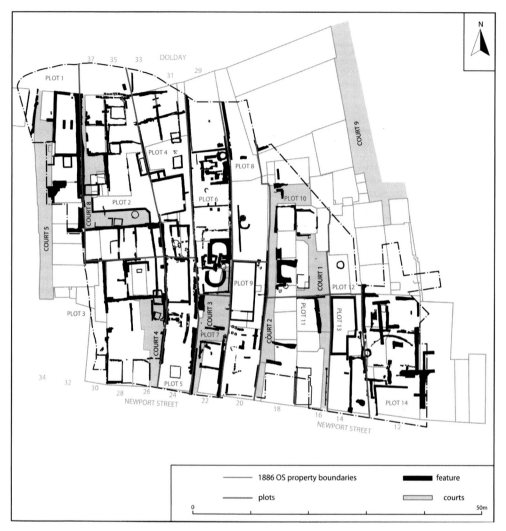

The main excavated structural features, Newport Street. This plan relates the results of the excavation to the fourteen plots and six courts shown on the 1886 Ordnance Survey map. At that time, much of the medieval pattern still survived, but it was mostly swept away by slum clearance in the early twentieth century. (Reproduced courtesy of Cotswold Archaeology and Worcestershire Archive and Archaeology Service; map Crown Copyright)

Eight plots along Newport Street were excavated. Originally these extended from Newport Street to Dolday, where smaller plots were later separated off. Each plot had its own complex history, with alleyways, buildings, yards and ovens and other features. From documents it has been possible to trace the history of ownership as well, in some cases back to 1550.

Features and finds relating to a wide range of late medieval and early post-medieval industries were represented, including tanning, baking, malting, dyeing, smithing, shoemaking and distilling. The bases of ovens and hearths were particularly frequent. Some were domestic, while others may have been for commercial baking. The majority, though, are likely to have industrial, including for heating dye vats. Oddly, there are many

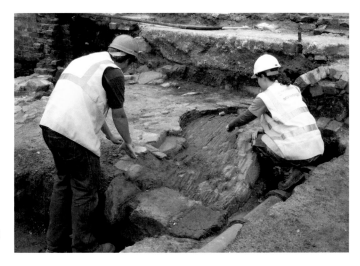

A late medieval oven in Plot 13, perhaps used to heat a dye vat. The oven floor was built of roof tiles on edge, set in clay, the wall of tiles and reused sandstone rubble. (Reproduced courtesy of Cotswold Archaeology and Worcestershire Archive and Archaeology Service)

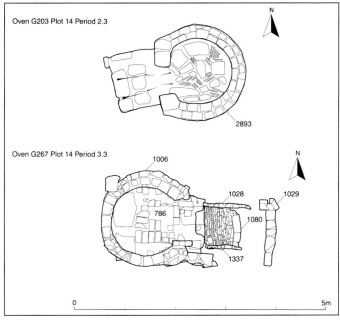

Plans of medieval and early post-medieval keyhole-shaped ovens, built of tile, stone and clay (G203, thirteenth/ fourteenth century; G267, seventeenth/eighteenth century). (Reproduced courtesy of Cotswold Archaeology and Worcestershire Archive and Archaeology Service)

documentary references to clothiers or weavers in the area, but none to dyers, though this would have been an essential part of the cloth industry. In contrast to dry-land sites in Worcester, rubbish pits were rare. Although pits were frequent, they generally appeared to be functional, including cesspits, and often had a clay, stone or tile lining.

Plots 4 and 5 (later Nos 31–33 Dolday and No. 24 Newport Street) provide a snapshot of the site. There were no courts on the plot itself, but buildings were accessed from Courts 3 and 4 to either side. Like many of the plots, its boundaries were marked on both sides by substantial stone walls, from at least the fourteenth century and perhaps earlier. The boundaries mapped by the Ordnance Survey in 1886 were still on the same alignment. Several late medieval ovens were excavated. One of these was exceptionally

large (2.5 metres long), with mortared tile walls; it was associated with a working area with pitched tile floors and a large stone block, set into the ground. A substantial stone building on the Newport Street frontage may have been of fourteenth-century date. A later owner, Edward Hurdman, who died in 1682, was a distiller. In a seventeenth-century cesspit at the back of the plot, a very varied assemblage of seeds and stones of fruits, spices and vegetables was found. Many of these could have been used in distilling: currant or gooseberry, grape, fig, cherry, plum, apple, rose, raspberry, medlar, coriander, black mustard, black pepper and fennel, cucumber, squash and buckwheat. Eighteenth-century inventories describe a malting kiln, malthouse, brewhouse and bakery, though the archaeological record for this period was scanty. In this and the following century the plot became densely built up with tenement housing. The Severn Galley inn (referencing the river trade on which much of Newport Street's economy depended) was first mentioned in 1739. There was still an inn here in 1907, then called the Boar's Head.

Surprisingly little pottery was found during the excavations. Medieval pottery included some imports from France and Spain, while there were interesting groups of pottery from seventeenth- and eighteenth-century pits, including Rhineland stoneware.

Medieval architectural stonework fragments probably derived from the demolition or rebuilding of neighbouring medieval churches, including All Saints, St Clement's and the Blackfriars church. Several decorated floor tiles may also have come from churches. Some elaborate stone candle holders may have been either made or used here. Millstones and stone troughs attest to industrial working, with broken millstones frequently used to cap disused wells.

The Newport Street excavation presents a lengthy sequence of occupation. Due to the limited excavation of deposits from earlier periods, only some of this can be understood in detail. Indeed, the majority of the site was unexcavated, and has been preserved under the new building. Even the waterlogged plant remains should survive for future generations to research, as the deeper layers are constantly replenished with river water.

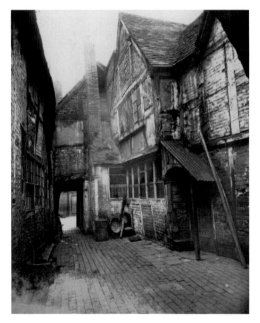

Standing archaeology: buildings in Court 4, Newport Street (excavation Plot 3), in 1936. The building on the left is in Plot 4, but was accessed from this court; the archway leads out on to Newport Street. The Worcester City Health Officer, A. D. McGuirk, took many of these atmospheric photographs to document the need for slum clearance. (A. D. McGuirk; image from Worcester City museum collection, reproduced courtesy of Worcester City Council and Museums Worcestershire)

Dig 14

The Commandery (2005–06)

A Medieval Hospital

The medieval building complex known as the Commandery opened as a museum in 1977. The displays have concentrated on the Civil War, when the building was a Royalist headquarters. They have also covered the thousand-year history of this fascinating group of buildings, as well as the wider history of Worcester.

The buildings have been thoroughly studied, both in the mid-nineteenth century and more recently. However, there had never been any archaeological work below the ground, apart from occasional watching briefs, until the turn of the twenty-first century.

Tree-ring dating has shown that the medieval buildings to be seen now, grouped around a courtyard, represent a comprehensive rebuilding between 1467 and 1473, with nothing left standing from the first 250 years or more of the medieval hospital's history. They comprise a Great Hall or refectory, the master's lodgings and a long wing now facing the canal. Buildings around a second courtyard to the north have nearly all gone.

In 2004, a grant from the Heritage Lottery Fund enabled a redisplay and repairs to the building. The project included archaeological excavation, with questions included on the layout of the missing late medieval buildings, the overall layout of the earlier hospital and specifically the location of the chapel and its possible origins in the late Anglo-Saxon period. Volunteers from the local community were invited to work alongside the professional archaeologists.

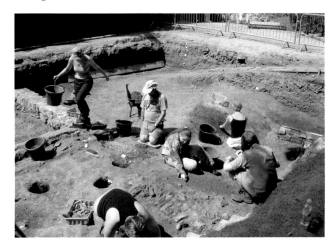

Volunteers at work in one of the excavation trenches at the Commandery, summer 2005. The stone foundations mark the wall lines of buildings forming the late medieval hospital's northern courtyard, which survived into the eighteenth century. (Reproduced courtesy of Museums Worcestershire and Worcestershire Archive and Archaeology Service)

A small evaluation trench in the east-wing kitchen found two burials. It was thought likely that they had been buried within the chapel. A geophysical survey followed, though with inconclusive results. The excavation campaign was planned, based on the availability of sites for trenching and on the existing understanding of the hospital's medieval layout. Only sample excavation was to be carried out, with the intention that the majority of remains would be left in situ. Seven trenches were excavated over two summer seasons in 2005 and 2006. The largest were to the north of the standing buildings, around the second courtyard. Most buildings surrounding this courtyard had been demolished by 1800. A single trench was dug within the southern courtyard, while two smaller trenches targeted the probable site of the chapel.

The northern trenches revealed the layout of buildings to the north of the Garden Wing, an early eighteenth-century extension which incorporates part of the medieval complex. Here there were one or more earlier medieval (thirteenth–fourteenth century) buildings. During the replanning of *c.* 1470, the second courtyard was built here; this was partially rebuilt in the sixteenth century, probably after the Dissolution, when the Wylde family occupied the Commandery as a private house.

The southern courtyard trench encountered a wall belonging to one of the earlier hospital buildings, as well as foundations for a demolished bay window, associated with the hospital master's house, which still stands.

The east end of the medieval chapel was found in two trenches, one outside and one inside the standing buildings. The walls were of good quality Highley stone, well dressed and with many masons' marks, and are thought to date to the thirteenth century. Buttresses clasped the corners and there was a chamfered plinth. To the north was a side chapel or vestry, built in the fourteenth century in a less good red sandstone. This was probably

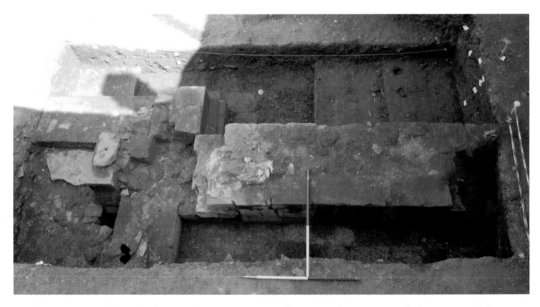

Looking down on the early thirteenth-century east wall and north-eastern angle buttresses of the Commandery chapel, excavated in 2006. Inside the chapel, the mortar bedding for floor tiles can be seen. To the left is a later medieval foundation for a side chapel or vestry. (Reproduced courtesy of Museums Worcestershire and Worcestershire Archive and Archaeology Service)

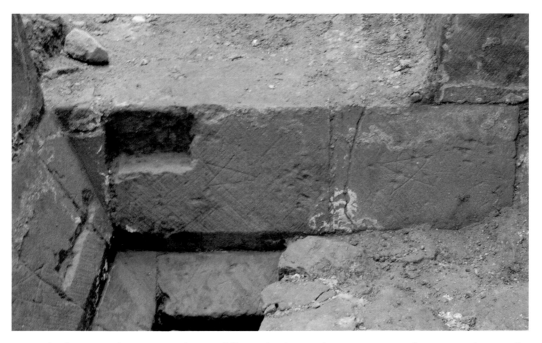

The five-pointed star is one of many different 'banker marks' or masons marks, cut into the stone by the thirteenth-century stonemasons who worked on the chapel. In all, nearly fifty marks were found on the chapel walls. Several of these can also be seen on stonework at Worcester Cathedral. (Reproduced courtesy of Museums Worcestershire and Worcestershire Archive and Archaeology Service)

demolished in the mid-sixteenth century to make way for the building of the Long Chamber, while the chapel itself survived until the rebuilding of the east front around 1700.

The excavations were not massive in extent but produced some very interesting finds. Among these is the largest excavated assemblage of medieval floor tiles from Worcester, many of them decorated. Two locations each produced nearly 200 tiles, with the total number from the site exceeding 450. A small number of tiles from the chapel area were of 'Westminster' type, probably thirteenth century in date. Widely distributed in the Midlands, these may either have been made in London or locally by itinerant tilemakers. Fourteenth-century Worcester tiles came from the chapel and its northern annexe or aisle. Malvern-style tiles, made in the fifteenth century, came from the late eighteenth-century demolition of a building north of the Great Hall, presumed to have been part of the 1467–73 rebuilding. These may have been made here by Malvern tilers or brought from a kiln in Malvern. In all, some 150 decorated tiles were found, in nearly fifty different patterns. Plain tiles were coloured in green, brown, black and yellow.

Other finds included medieval coins and jettons, a book clasp or strap end, and a spur. The medieval pottery from the site was mainly from the Malvern and Worcester industries, with very small quantities of wares traded from further afield. Building stone fragments included part of a limestone roof finial cross and a fragment of a column, richly decorated with red paint and gold leaf.

There is clearly much more to learn about the shadowy earlier development of this fascinating site. Crucially, the Commandery excavations have revealed the site's potential, while leaving most of the remains in the ground for future researchers.

Left: A floor tile depicting a dragon-like creature, probably a wyvern (with two legs, wings and a long tail). Wyverns were common in medieval heraldry. This tile was made in Worcester, and probably formed part of a decorated floor in the Commandery's chapel. (Reproduced courtesy of Museums Worcestershire and Worcestershire Archive and Archaeology Service)

Below: Freshly excavated from the ground, this fragment of a column shaft is probably from a door or window opening. The stone was painted red and also gilded, hinting at an opulent lifestyle in the medieval Commandery. (Reproduced courtesy of Museums Worcestershire and Worcestershire Archive and Archaeology Service)

Dig 15

The University of Worcester City Campus (2007–12)

Dissection and Surgical Training in the Early Nineteenth Century

The University of Worcester's City Campus was the site of the Worcester Royal Infirmary from 1771 to 2002. Redevelopment since then has involved the demolition of nearly all the twentieth-century hospital buildings, and the conversion of the main eighteenth- and nineteenth-century infirmary building for teaching and offices. Plans for the site included much more than the two residential blocks built so far, and further development is likely to follow in due course.

Archaeology revealed two main periods of interest, separated by millennia: Roman (first to fourth century AD) and nineteenth century. The campus site lies towards the north-western edge of the Roman town. The later remains relate very specifically to the hospital.

Initial investigation in 2007–08 was by a large number of small trenches, between the hospital buildings, which were tightly packed across the site. Roman remains were widely preserved, though absent from some areas due to terracing.

Excavation followed in 2009–12, in the area of the first phase of development. In other parts of the site, especially at the lower end (on the edge of the Severn floodplain), deeply buried Roman deposits and features have been identified but await future investigation. The results have been published as online monograph reports, with shorter reports in the county archaeological journal. Detailed records have also been made of all the buildings.

A few sherds of late Bronze Age or Iron Age pottery were found, in later features. More concentrated activity began after the Roman conquest, at a fairly low level in the first and early second centuries AD, and peaking in the later second to later third. Foundations of two buildings were found, both thought to have had an agricultural function. One was a post-built structure. The other had trenches for sill beams; preserved plant remains suggested it was a barn used for crop processing. A circular ditched feature remains a mystery.

Most of the Roman features were small pits, which had been dug to obtain sand and gravel for building. Intercutting pits clustered together in two main groups, both from the mid-Roman period. As at the nearby Magistrates' Court site (Dig 10), there was then widespread dumping of rubbish, seemingly brought in from across the settlement.

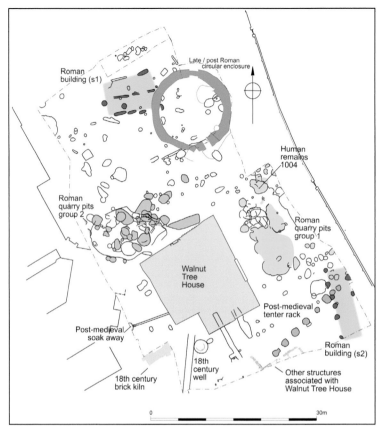

Roman building (s1)

Late / post Roman circular enclosure

Human remains 1004

Roman quarry pits group 2

Roman quarry pits group 1

Walnut Tree House

Post-medieval tenter rack

Post-medieval soak away

Roman building (s2)

18th century well

Other structures associated with Walnut Tree House

18th century brick kiln

0 30m

Left: Plan of Roman and later features from the main excavation at the south-east corner of the University of Worcester's City Campus site. (Reproduced courtesy of Worcestershire Archive and Archaeology Service)

Below: Excavation underway at the City Campus site. The circular ditched feature seen here is Roman in date, but its purpose is still unexplained. (Reproduced courtesy of Worcestershire Archive and Archaeology Service)

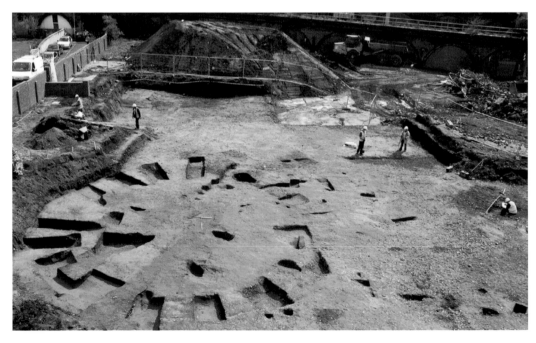

The finds assemblages were mostly domestic in nature. Unusually for Worcester, there was very little industrial waste. Higher-status material included decorated Samian tableware imported from Gaul. Other finds included parts of the ceramic ovens which were so frequent at the Hive (Dig 18). Bone-working debris relates to a craft which could be carried out in the home. One pit contained substantially complete fragments of six *mortaria* (mixing bowls) in Oxfordshire white ware, surely a trader's stock which had been damaged and become unsaleable. Distinctive among the animal bones was a large number of bones from small dogs, of a similar size to the modern Corgi and perhaps bred, like them, for cattle herding.

Later features were quite scarce in this area, but included a line of postholes which probably supported a tenter rack for drying cloth. Typically these needed to be 25 yards long, and the postholes found spanned three-quarters this length. The use of tenter racks is well documented in Worcester, but this is the first time one has been excavated.

However, the most exciting results from the post-medieval period came from watching briefs around the eighteenth-century hospital building. Four pits, three of them near the back of the building, had been used for the disposal of disarticulated human remains and surgical instruments. The findings have important stories to tell about early surgical training methods, legal restrictions and the treatment of the dead.

Charles Hastings, who convened a meeting here in 1832 that led to the foundation of the British Medical Association, was a key figure in the development of modern surgical practice in the early nineteenth century. Anatomy and surgical techniques could only be taught effectively with the use of human cadavers, but prior to the 1832 Anatomy Act, bodies were hard to come by. Executed felons constituted one of the few legal sources of cadavers for dissection. In 1813, a new prison was built on the north side of Salt Lane (renamed Castle Street after the castellated prison gatehouse). Careful provision was

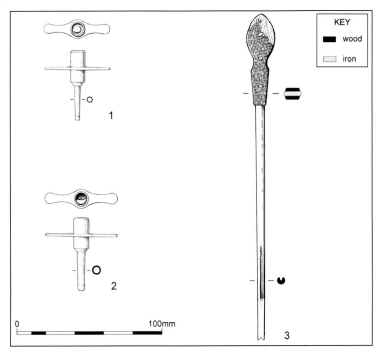

Nineteenth-century surgical instruments excavated at Worcester Infirmary (City Campus): urethral stricture dilators and an ebony-handled uterine or bladder sound. Other finds from the pits related to food and drink preparation and storage. (Reproduced courtesy of Worcestershire Archive and Archaeology Service)

made for the infirmary to receive bodies, discreetly. Bodies were taken from the prison to the infirmary through a tunnel, built under the street. Several death masks of prisoners, found here, are now in the George Marshall Museum.

Clearly, what was found is only a small sample of the 'output' from the hospital, but it is a fascinating cross-section of activity. Formal teaching is represented by bones mounted as part of skeletons for display. Other bones have been sawn and are probably from amputated limbs; amputation became a specialism of the Worcester infirmary. Other bones have saw and cut marks consistent with either post-mortem examination or dissection, which use very similar techniques. It is also tempting to conclude that some of the sawn bones found, including 'false kerfs' (abandoned saw cuts), were the work of inexperienced students.

The remains reflect a wide variety of activities, within a relatively small assemblage, and the bones could have been accumulated over a period of time before disposal. Similar deposits have been found at several of the London and regional hospitals. The Worcester collection is contributing new information on medical and surgical practices, and surgical training, at a very important time in medical history.

Ball joint of a femur, drilled and with iron and copper fixings. This would have supported the skeleton for display. (Reproduced courtesy of Gaynor Western, Ossafreelance, and Worcestershire Archive and Archaeology Service)

Evidence of a 'Carden amputation': the sawn-off and discarded distal end of a femur. This technique was developed from 1846 by Henry Carden at Worcester Infirmary. Here, the patient's leg has been amputated just above the knee. (Reproduced courtesy of Gaynor Western, Ossafreelance, and Worcestershire Archive and Archaeology Service)

Dig 16

Swanpool Walk, St John's (2007–08)

Trading and Provisioning in the First and Twenty-first Centuries

The year 2007 saw archaeological work in a previously unexplored part of Worcester, before the construction of a new Sainsbury's store on the edge of the medieval suburb of St John's, west of the Severn. Previously, nothing was known from the site itself. A few hints from neighbouring areas were not easily interpretable, and everyone was surprised that it was not the medieval discoveries here which caught the eye.

The large site overlapped with the medieval suburb, which consists of burgage plots along the Bull Ring, St John's and Malvern Road. It extended across backlands, once occupied by orchards, but more recently by a tennis club, sports centre and council depot. This area is on the edge of a wide, low gravel terrace with excellent views over the Severn floodplain towards the city centre.

As often happens on urban developments, the site was in full use until contractors started demolition, and construction was scheduled to follow straight away. There was

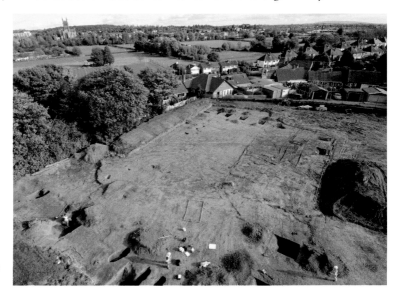

Excavation of the Roman enclosure at Swanpool Walk, looking south-east across the Severn floodplain towards Worcester Cathedral and the city centre. The later graves can be seen at bottom left. (Reproduced courtesy of Worcestershire Archive and Archaeology Service and Aerial-Cam)

no opportunity for early evaluation trenching and relaxed consideration of the results. Trenches were dug as soon as areas became available, and decisions on what should be done had to be made immediately to avoid delaying the build programme.

In the former council depot, at the very south of the suburb, the early discoveries were largely as expected. Here there were medieval ovens, and also pits and other features associated with eighteenth- or nineteenth-century tanning, including large numbers of cattle horn cores; presumably horn-working was a by-product.

The most significant results were from the eastern end of the site, where a roughly square ditched enclosure was found, its sides measuring about 40 metres. The enclosure had origins in the late Iron Age (either side of AD 0), or possibly earlier in the middle Iron Age. Around the middle of the first century AD (probably in the late 40s) things became much more interesting. The ditch was recut and presumably a rampart was built. Finds dated this phase closely to the reigns of emperors Claudius (AD 41–54) and Nero (54–68), the period when the Roman invaders had just arrived in the western Midlands. The finds included six coins of Claudius, and a contemporary coin of ESUP RASU. A group of Claudio-Neronian brooches probably indicate a military presence. Pottery included diagnostically early Roman forms, some influenced by Belgic styles from south-east England, though mostly handmade or wheel-thrown by potters in the Malvern area. Five large storage jars had graffiti cut into them. These marks were not writing, but it has been suggested that they were marks of ownership. This is the largest collection of conquest-period objects yet to have been found in Worcester.

The site seems to represent a point of early contact between the Roman military (presumably established in Worcester itself) and the Celtic peoples of the land to the west. This may be where people brought produce to trade with the conquerors. The finds all seem to have been dumped when the site was abandoned in the AD 50s.

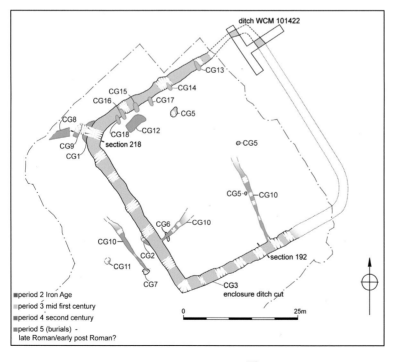

Swanpool Walk: plan of the Roman enclosure and excavated features of Iron Age, Roman and potentially Dark Age date. The northern corner had been found during a previous and unrelated project, when the ditches were thought to be field ditches. (Reproduced courtesy of Worcestershire Archive and Archaeology Service)

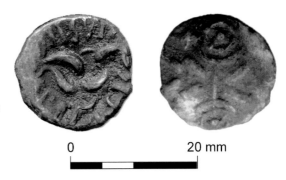

Gold-plated stater of ESUP RASU of the Corieltauvi. As with most other leaders of the late Iron Age, the existence of ESUP RASU is known only from coins. The double name could indicate joint rulers rather than one person. The Corieltauvi were an Iron Age tribe in the east Midlands with a tribal centre at Leicester. Their coins were based on coins from ancient Greece. (Reproduced courtesy of Worcestershire Archive and Archaeology Service)

0 20 mm

The enclosure was reoccupied in the second century AD, when there is evidence for smithing, probably of iron smelted at Worcester itself. A later phase consisted of a small cemetery of six graves, dug into the backfilled ditch – the rampart would still have been visible. They were aligned north–south so are unlikely to have been Christian. Four still contained skeletons; one was buried prone (face down) and one was decapitated. Two were buried wearing hobnailed boots. The burials were dated by radiocarbon to the fourth to sixth centuries AD, so could have been from either before or after the departure of the Romans at the beginning of the fifth century.

Luckily the enclosure was in an area intended for car parking. After excavation was complete, all unexcavated parts of the ditches and other features were protected, and are now hidden below the supermarket car park.

The archaeological discoveries on this site have left an artistic legacy. As part of an arts and heritage trail created by Planet Art for the Sainsbury's development, two sculptures and six plaques illustrating local history and archaeology have been installed in St John's, signposting a walk between Pitmaston Park and Cripplegate Park.

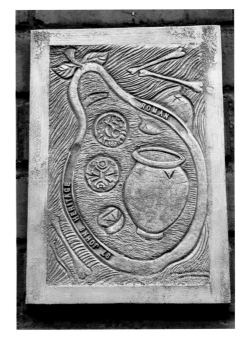

Fixed to a wall of Sainsbury's store, this is one of two plaques in the St John's Arts and Heritage Trail based on archaeological finds from the site. The design includes pots, the Iron Age coins and burials. Another plaque illustrates the post-medieval tanning workshop located close to Malvern Road. (Reproduced courtesy of 'Planet Art'; Julie Edwards and Ron Thompson)

Dig 17

King's SPACE and Worcester Castle (2007–12)

The Origins of Worcester Revisited

175 years after Worcester's castle disappeared from the townscape (Dig 1), archaeological excavations have begun to bring it out of obscurity, thanks largely to developments by the King's School, who occupy most of its site. Excavations here have connected the Norman castle to the longer history of the origins of Worcester, unexpectedly extending that history by several centuries.

At School House, excavation before the building of a library extension recorded a single Iron Age pit, containing pottery from the Malverns. This site also produced some worked flints, and significant quantities of Roman finds, though all had been disturbed by gravel digging. Nearby, at Castle House, excavation and building recording identified a medieval stone wall, now incorporated into a later building, as part of a late twelfth-century chamber block, built within the bailey.

However, the most exciting discoveries have been at the SPACE site. The development was for a sports hall with underground car parking, on the north side of Severn Street. The site was excavated in stages, with the main work in 2007, 2009 and 2012. Most work was done by Mike Napthan Archaeology, with some by Worcestershire Archaeology.

Although the deep fills of the castle ditch were anticipated, it was not expected that much of the bailey rampart would survive. In the event, the excavation was dominated by both of these massive features. Although the two had a common origin, and a common function through most of their extremely long lifespan, archaeologically they appear quite disconnected. To remain effective, a ditch must be regularly cleaned out, so the ditch and its fills largely reflect its later history. In contrast, the rampart would have been added to over time; the surviving remains were all from its earliest construction.

Barker's work at Lich Street (Dig 3) had established that the Roman defences there had origins extending back into later prehistory, but there was nothing to suggest that the rampart was earlier than the two or three centuries before the Roman conquest. Here, however, radiocarbon dates from the remains of charred posts found within the rampart suggested a much earlier origin; the earthwork was probably first constructed between the seventh and fifth centuries BC. It was no simple construction either, but a complex timber-laced rampart, on a scale comparable to those found at contemporary local hillforts such as Midsummer Hill and Kemerton Camp.

Flints and pottery found in a soil layer sealed below the rampart gave a late Neolithic date, though there were no features or other indications of occupation in the area.

The earliest rampart excavated here was built of gravel, retained by a structure of 28–40-centimetre-diameter timbers with charred ends, set in a deep slot. Very little of this was seen. In a second phase the rampart was greatly enlarged, and revetted with a palisade, though again only part of it (the outer 5–6 metres) was seen in excavation.

Below a modern embankment, the rampart survived to a height of 2.8 metres. None of it could be dated to any later than the Iron Age. In later periods it was no doubt added to, probably crowned by palisades or walls, but nothing of this survived. The full width of the rampart is estimated to be nearly 20 metres, of which about one-third lay within the site.

The ditch sequence has been reconstructed from several trenches and a number of boreholes, and there was no single excavated section across the ditch (or, as it emerged, ditches). The section shows two principal ditches, side by side. The inner, earlier and smaller ditch contained Roman pottery and may have had Iron Age origins. This was seen in boreholes only and was perhaps 13 metres wide and 4 metres deep, very much smaller than the ditch seen at Lich Street. It was cut away on its outer edge by the medieval ditch, itself 18–20 metres wide and 5.5 metres deep, with basal fills dated to the tenth to twelfth centuries AD. By the seventeenth century the ditch was largely infilled, and a smaller ditch was dug as part of the Civil War defences, about 11 metres wide and 3.5 metres deep.

Before the SPACE excavation, the alignment of the southern side of the Roman town's fortification was not certain, and various lines had been proposed. A more northerly line had generally been favoured, due to the belief that the land just north of Severn Street had been occupied by a Roman cemetery; such features were normally sited just outside towns. However, the continuity of use demonstrated here is strong circumstantial evidence that the earthwork continued in use on this alignment throughout the Roman period.

This places the Anglo-Saxon cathedral centrally within the retained earthwork, which would have been reused as a defence for the first *burh* in the ninth century; this was

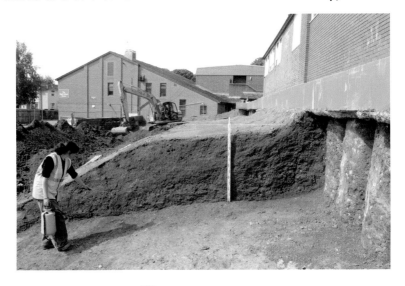

One of the excavated sections through the rampart. A line of darker reddish fill in front of the section shows the location of a palisade slot, awaiting excavation. (Reproduced courtesy of Mike Napthan)

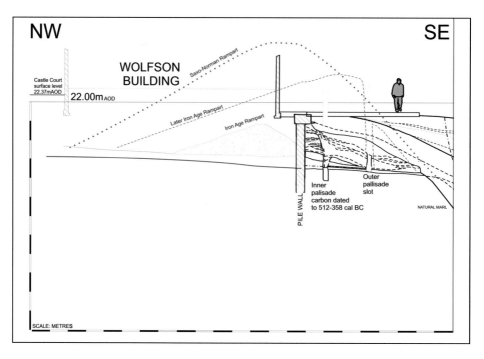

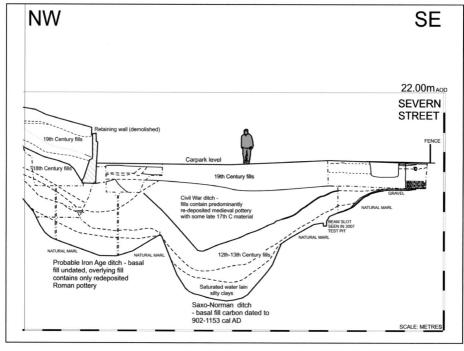

King's SPACE site: this composite cross-section is derived from excavated evidence and boreholes. The ramparts can be seen in the left-hand part, the ditches mainly in the right-hand half. The heights and inner edges of the ramparts are conjectural. (Reproduced courtesy of Mike Napthan)

presumably when the new ditch was dug out. The southern side remained on the same alignment when the *burh* was extended to the north at the end of the century.

The medieval castle occupied land to the south of the cathedral, including most of College Green, which was expropriated from the priory in 1069. It reused the earthwork rampart and ditch along its southern side. The northern part of this land was returned to the priory in 1217, leaving the castle without effective defences on that side.

The defences saw their final period of use during the Civil War, when Worcester was strongly defended by the Royalists. The castle defences were refurbished, and an outer defensive line was created, whose ditches have been found on the south side of Severn Street. The 1651 map shows these features, including entrenchments on the motte. Thereafter, prison buildings were constructed in the bailey, enclosed by a wall along the approximate line of the rampart.

Excavation here extended the story of Worcester by about 500 years, and showed how the defensive sequence worked. While the defences have not been in continuous use for two and a half millennia, their physical presence has shaped the developing city. The SPACE development highlighted the survival and excellent preservation of the rampart, albeit by destroying part of it. The rampart probably survives under the buildings to the north, as well as to either side, in between twentieth-century developments.

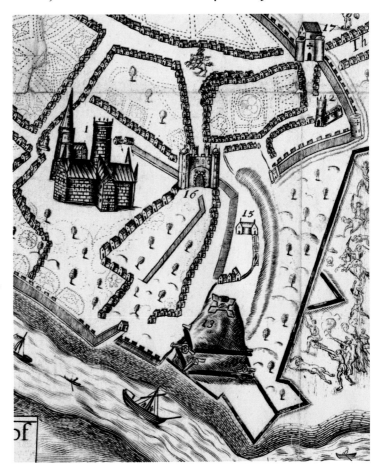

Extract from *An exact ground-plot of ye City of Worcester as it stood fortifyd, 3 Sept. 1651* (Robert Vaughan, published 1662), showing the castle and the area around. The refortification of the motte can be seen, along with the additional defensive line with bastions which was added to the south. (British Museum: public domain)

Dig 18

The Hive and The Butts
(2006–11)

Trouble Finally Repaid

In 1828, Edwin Lees published the *Stranger's Guide to Worcester* ('including a concise description of every remarkable & interesting object contained therein'), under the pseudonym of Ambrose Florence. He was keen to establish the Roman origins of Worcester, commenting that 'it has been rather hastily concluded by some authors that the Romans had little to do with Worcester'. He returned to the subject towards the end of his book, where he suggested 'the more particular examination of the rising tract of ground along the line of the Butts, from old St Clement's Church to Angel Street, it is not improbable their trouble might be repaid'. It is not known what inspired this prediction, whether supposition or evidence. If the latter, he did not share it. He may have been disappointed by the lack of reaction; it was to be nearly 200 years before his claims were tested.

This has long been a marginal area. It lies just outside the city walls, and the open land was used by medieval weavers for drying their cloths on tenter frames. The street name 'The Butts' could derive from medieval archery butts (alternatively it may signify gravel quarrying). After the disuse of the defences, the area was developed for small-scale

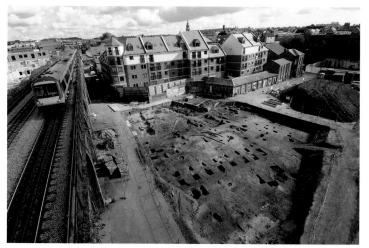

View of the Hive excavation, looking east. Foundations and other features from several buildings can be seen. These are aligned along a road which led towards the riverside, its line marked in this view by a ditch close to the northern (left-hand) edge of the excavation. (Reproduced courtesy of Worcestershire Archive and Archaeology Service and Aerial-Cam)

industry, and later the nineteenth-century cattle market. In the early 2000s, residential developments started to change the street.

Archaeological remains have now been found on several sites along The Butts. In 2001, a Roman well was found at No. 1 The Butts, in a narrow undisturbed strip between the city wall and ditch. The well was lined in red sandstone blocks, probably reused. The upper fills contained a small hoard of nine late Roman coins and worked stone (including part of a column), tesserae, painted wall plaster and other building materials, as well as a rare fragment of multicoloured 'snake-trail' glass from the Rhineland. The backfilling of the well dated to AD 370–90. The finds seem to indicate the destruction of a building by burning.

Over the road, at Magdala Court, another Roman sandstone-lined well was found, as well as a road surface. Civil War ditches crossed this site and have also been found on the neighbouring sites.

The largest excavation took place before the building of the Hive. The site was a busy city depot and car park, when Worcestershire County Council and the University of Worcester first conceived the idea of a joint public and university library. The county's archive and archaeological services soon joined the project, and the archaeological implications were addressed very early on. Two early phases of evaluation, in 2006 and 2007, consisted of very small (2 by 2 metre) trenches in the depot. Digging started as soon as the bin lorries left in the morning, with the trenches completed and backfilled before the lorries returned in the afternoon. Even from these small trenches, it was clear that Roman remains were extensive across the site, and that a significant programme of excavation would be needed.

The development was funded by the government's Private Finance Initiative, to be delivered by a private consortium. This required a 'risk-free' site, so the archaeological excavation was completed before the site was handed over. As this was a public scheme, community involvement was at the forefront throughout. The first phase of excavation was undertaken by a team of volunteers in summer 2008. The rest of the site was dug by professional archaeologists, and the site remained open to the public, with displays of finds and daily site tours.

The main focus of the excavation was the Roman period. Closer in to the city centre, Roman remains are often very fragmentary, cut away by the pits and ditches

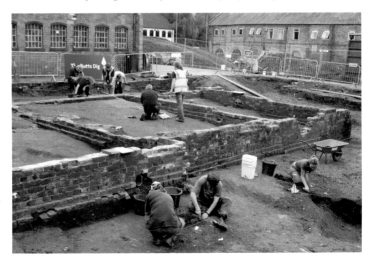

Volunteers excavating the foundations of the nineteenth-century Nash's Almshouses. In the background are the sawmill and workshops of Joseph Wood's builder's yard. (Reproduced courtesy of Worcestershire Archive and Archaeology Service)

of later periods. Here that was not the case; after the Roman period there was no intensive occupation until the beginning of the nineteenth century. The preservation of building foundations, floors and other features was exceptional. Several buildings were excavated, facing a road which probably linked the town to a quay and river crossing on the Severn. Further south on the site Roman remains were absent. This was probably a genuinely empty area, though it is also possible that a low hill had later been levelled off, taking archaeological remains with it.

Occupation was dated to between the late first and late fourth centuries, and concentrated between AD 150 and 300. The road alignment persisted for the whole period, with up to four phases of buildings along it. Most buildings were represented by clay and stone floor surfaces, ovens and hearths. They were rectangular, with a narrow end facing the road, a relatively 'urban' layout.

The largest structure on the site was a sizeable aisled building, with external dimensions of 22 by 11 metres. The foundations comprised strips and pads, dug out and packed with marl. The only internal feature was a single oven in the centre. Next to the building were two massive pits, probably the source of marl for the foundations.

Further from the road was a stone foundation, 2.5 metres square, probably for a malting kiln, with a timber shelter around it. This modest structure was fully excavated, and has been reassembled inside the Hive, stone by stone.

The marl-filled outer foundation trenches (excavated in alternate sections) and aisle post-pads (half-sectioned) of a large late Roman building, of uncertain function. It faced a road which crossed at the bottom of the picture. The large pits from which the marl was dug can be seen top left, partly excavated, and are cut by a Civil War ditch. (Reproduced courtesy of Worcestershire Archive and Archaeology Service and Aerial-Cam)

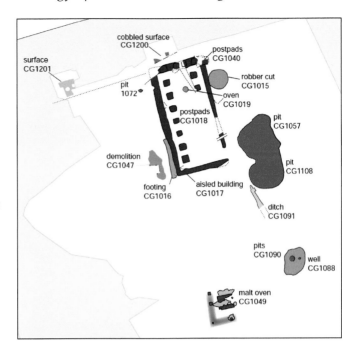

The Hive excavation: extract from a plan showing the site layout in Period 6 (fourth century AD), including the road surface, large aisled building, quarry pits for clay and malting kiln. (Reproduced courtesy of Worcestershire Archive and Archaeology Service)

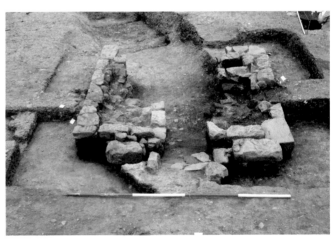

Stone foundations of a fourth-century kiln, probably for malting. The square structure encloses a flue, probably T-shaped. The foundations were dismantled during the excavation, and have been reconstructed inside the Hive. This is the only structure from Roman Worcester which can be visited. (Reproduced courtesy of Worcestershire Archive and Archaeology Service)

125 metres to the west of the main site, on the riverside, a 7-metre-deep shaft was excavated. The river bank has scarcely moved since Roman times, when massive quantities of iron slag were dumped here, to a depth of over 3 metres. A post, driven into the bank here, may have been a mooring post, or part of a revetment.

The assemblage of finds from the Hive was dominated (in quantity) by 5 tonnes of iron slag and almost a tonne of Roman pottery. Other finds included a clay antefix (gable decoration), depicting a female head. There were large quantities of ceramic and stone building materials (in particular hexagonal stone roof tiles) and wall plaster.

Many Roman sites in Worcestershire have produced fragments of unusual large ceramic vessels, whose original form had proved elusive until the Hive excavation. Here enough were found together to reconstruct their form, showing that the 'vessels'

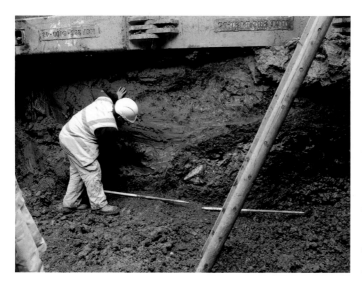

125 metres west of the main Hive site, a deep shaft was dug on the riverside to provide a water intake for the building's heating system. Huge quantities of iron slag had been dumped over the river bank during the Roman period. Part of the slag dump can be seen on the right-hand side of this view, overlaid by orange and grey river deposits. (Reproduced courtesy of Worcestershire Archive and Archaeology Service)

were in fact ceramic ovens. The ovens were prefabricated, probably in the Malvern area, and once set up on site would have been covered with an insulating layer of clay. Experimental reconstructions have shown that they could be used for a wide variety of foods, including roast meats or flatbread (similar to pizza).

Isotope analysis (strontium, oxygen and carbon) of cattle bones from the site suggested that some animals had lived and grazed south or west of Worcester (Herefordshire, South West England or South Wales). The cattle would have been driven to market in Worcester, prefiguring the drovers of later times.

The dig included the first section excavated across the city ditch since 1973. The medieval ditch was 10 metres wide and 5 metres deep. Finds from the fills dated to the fifteenth–sixteenth centuries and relate to probable neglect of the defences and partial infilling of the ditch in this period. The Civil War saw rebuilding and enlargement of Worcester's defences, from 1642 onwards; defence of the Severn crossing was seen as particularly important. The ditch was re-dug, on a slightly smaller scale than the medieval ditch. Outside the medieval alignment, additional defences were provided. These consisted of bastions, including one just to the east of the Hive, which survived as a large infilled ditch. The existence of bastions was known from the 1651 map. What were less expected were further features, comprising zig-zag and straight ditch traces, extending outwards to cover a 60-metre-wide defensive zone.

Within the ditch was the medieval wall, here a retaining wall against ground which was over 2 metres higher to the south. The wall has been patched and rebuilt in stone, and later brick, and at this point retains little of its medieval appearance. Inside the wall was a roughly built buttress which may have been associated with the additional defences built in this area in 1646 (Dig 4).

Careful work on foundations and construction levels meant that a large part of the site could be left unexcavated, preserved below the new building, and pierced only by foundation piles. In contrast to other developments, where limiting excavation to the areas of impact has led to a very fragmentary understanding of the site sequence, here the understanding of most periods is very thorough. The archaeological discoveries provided a suitable foundation for a building which contains the county archives and Historic Environment Record.

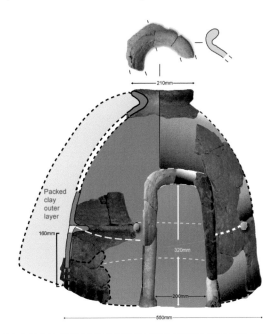

Reconstruction of a large portable ceramic oven, of a type common in Roman Worcestershire. These ovens were characterised by a tall aperture for stoking, loading and unloading, internal ledges to hold grills or baking plates and a chimney opening at the top, shaped like a pot rim. (Reproduced courtesy of Worcestershire Archive and Archaeology Service)

Based on the finds from the Hive, a portable oven was made by Graham Taylor, a potter who specialises in recreations of Roman pottery. An experimental cooking session by Sally Granger showed that it would work effectively for roasting or grilling meat or vegetables, or for baking bread. (Reproduced courtesy of Jane Evans)

Dig 19

St Martin's Quarter (2009–12)

Lowesmoor's 2000 Years of Industry

In medieval times, the suburbs were where all the most noxious and dangerous industries tended to congregate. Lowesmoor (and Silver Street), outside St Martin's Gate and on the road to Droitwich, was no exception. Here, in the once-marshy valley of the Frog Brook, archaeology has revealed much evidence of industries, not just medieval, but also Roman and more recent. Most finds have come from a lengthy programme of recording which accompanied the redevelopment of the former Lowesmoor Trading Estate into the St Martin's Quarter shopping precinct. This area had become built up during the nineteenth century, including the sprawling Hill Evans vinegar works, once the largest in the world. This is a whole city district rather than a single site, comprising over 2.5 hectares on the edge of the medieval city.

The area has some history of archaeological investigation. Trenching in 1989 in Silver Street encountered large numbers of decorated floor-tile wasters, backing up documentary evidence for a medieval tile industry, and hinting at the likelihood of more substantial remains. Evaluation trenching in 2002 revealed the excellent preservation of remains of the nineteenth-century Grainger porcelain works. Roman features and iron slag were also found on the corner of City Walls Road and St Martin's Gate, as well as a very large ditch, which was recognised as part of the Civil War defences.

Further evaluation took place in 2009. Archaeologists, architects and engineers then worked together on a plan to preserve archaeological remains. Most of the buildings are on piled foundations, and excavation was only needed in three locations. Two of these, in the north-west and south-east of the site, were where remains were close to the surface, and particularly sensitive to damage from foundations. In the south-western corner of the site a deep rainwater attenuation tank was needed, and this gave the opportunity to investigate the Civil War ditch in detail. Watching briefs followed service trenches across the site, as well as foundations in some areas. The foundation design has preserved remains under much of the development, though the limited extent of excavation over most of the site makes it difficult to interpret some of the excavated features.

Roman road surfaces were found in two places, corresponding to the predicted alignment of a road from Droitwich to Worcester. They followed the pattern which is now expected in Worcester, with early stone and gravel surfaces, later replaced by

multiple layers of iron slag. Ironworking evidence nearby has included smelting and smithing slag and fragmentary hearths.

The post-Roman period was represented only by a single pit, containing a few sherds of ninth–tenth-century pottery. Evidence of occupation did not return until the suburb was established in the thirteenth century, when house plots were laid out and defined by ditches, and industrial activity began again.

A large medieval tile kiln comprised an oval structure with a stoke pit and flue, all built of flat roof tiles. This was close to the 1989 trenches, giving some confidence that this kiln was used to fire decorated floor tiles. Tiles in the patterns made here in the fourteenth century were used in Worcester Cathedral and in churches across the county. Worcester-made tiles were also traded to Bristol and along the South Wales coast as far as Pembrokeshire.

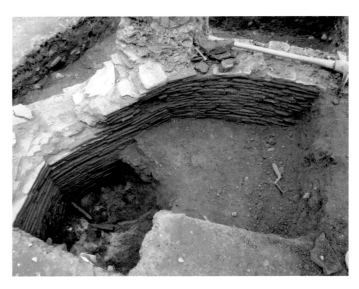

The excavated thirteenth-century kiln at Silver Street. In the foreground is a stoke pit, with the kiln itself at top left. The walls are built using flat roof tiles, but all of the kiln superstructure is lost. This kiln was probably used to fire both roof and floor tiles. (Reproduced courtesy of Worcestershire Archive and Archaeology Service)

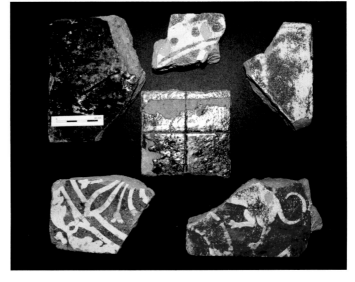

A selection of the decorated and undecorated (glazed) medieval floor tiles found at Silver Street. These tiles may well have been made in the excavated kiln. All of the tiles found here were wasters, discarded following damage in manufacture. (Reproduced courtesy of Worcestershire Archive and Archaeology Service)

A massive late sixteenth- to early seventeenth-century kiln was found in the attenuation tank trench. It was brick-built and can be identified with a documented brickworks belonging to the Marson family. No doubt roof tiles were also made here. It had an accompanying limekiln, and fragments of limestone masonry may have been brought from a demolished monastic building to be burnt here.

A group of very large limestone blocks had been dumped close to Lowesmoor. Some of them had mouldings suggesting that they formed part of a large doorway or archway. No large medieval structures are known from the immediate vicinity, and it is more likely that they came from a demolished building in the city centre, very possibly St Martin's Gate, which stood until 1787.

Given the quite limited size of the areas investigated, the evidence shows that industrial activity in parts of the site must have been very intensive. Along the east side of Silver Street, in addition to the two kilns mentioned above, remains of two tile kilns and a nineteenth-century clay tobacco-pipe kiln were found, as well as mould fragments probably related to a documented post-medieval bell foundry.

The Civil War ditch was shown to be part of an angular bastion, one of several which were added to the defences in the 1640s, as shown on the 1651 map. This bastion was built to defend St Martin's Gate and is presumably the St Martin's Sconce mentioned by Townshend in his diary covering the war years. He recorded its role in defending against the lengthy siege of May–July 1646. On 2 June a 'great culverin of iron at St Martin's sconce' exploded, killing a gunner and injuring others, and artillery fire from the sconce is recorded on 6 and 11 June. On the latter day, a Parliamentary 'bullet' (cannonball) 'went two foot into the mud wall at St Martin's sconce'. A cannonball was indeed found, though unfortunately not stratified in a Civil War deposit. The excavated ditch was up to 9 metres wide and over 3 metres deep, with holes in its outer slope showing where sharpened stakes may have been driven. Tip lines in the infilled ditch clearly showed where the bastion rampart had been pushed back into the ditch when the war was over. It seems that the bastion was built around a timber-framed building, the Angel Inn, which was only demolished in 1972. Because of its location it had been allowed to remain when the other buildings in the suburb were cleared to make the city more defensible.

The Grainger porcelain factory was founded in the early 1800s in competition with Royal Worcester, and closed in 1901. Some buildings were demolished to make way

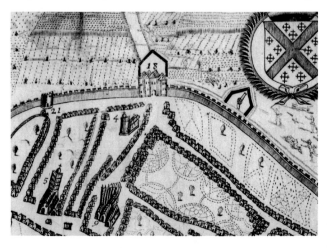

Extract from *An exact ground-plot of ye City of Worcester as it stood fortifyd, 3 Sept. 1651* (Robert Vaughan, published 1662). This detail includes St Martin's Gate and church, as well as the bastion built to defend the gate ('St Martin's Sconce'). (British Museum: public domain)

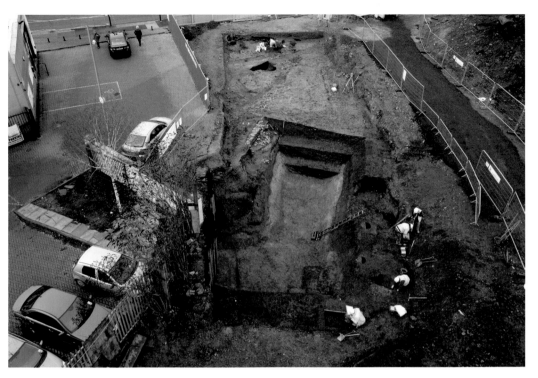

High-level view of the excavation of the Civil War bastion ditch. To the left of the ditch (and within the bastion), some of the brick foundations of the Merson brick and tile kiln can be seen. The kiln was destroyed to build the bastion, and not rebuilt after the Civil War. (Reproduced courtesy of Worcestershire Archive and Archaeology Service and Aerial-Cam)

The section excavated through the Civil War bastion ditch. Tip lines in the ditch fill show where the rampart, which had stood to the left of the ditch, was used to backfill it, in 1651 or shortly afterwards, when the defences were no longer needed. The dark layers cut by the ditch represent the accumulation of medieval to early seventeenth-century domestic and industrial waste. (Reproduced courtesy of Worcestershire Archive and Archaeology Service)

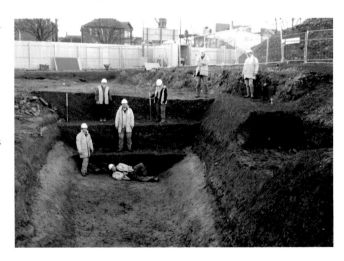

for the development, though part of a surviving kiln hovel (the only one remaining in Worcester) was retained and rebuilt. The below-ground structures of that kiln and five others were found, just below ground level. The new foundations were designed to minimise damage, and after recording, the remains were reburied. The kiln bases

show a great variation in construction, reflecting their different uses. Complex brickwork structures, several courses deep, allowed the hot air to circulate below the kiln itself. Within the hovels, most of the kilns were surrounded by a brick-paved passageway, heavily worn by the workers' boots. One of the kilns started life in this form, but was later adapted as an enamelling kiln, with smaller kiln bases in a row inside the hovel.

The 2000-year industrial history of this site is remarkable. It now has a new life as an extension to the city's retail core, with many of the nineteenth-century buildings remaining to tell of the area's industrial past.

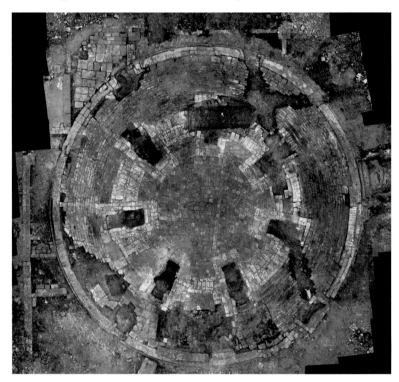

Grainger's porcelain works: a vertical view of the substructure and foundations of one of the mid-nine-teenth-century kilns during excavation. Within the outer hovel wall are a brick-paved passageway, a series of fireboxes and the central kiln floor. (Reproduced courtesy of Worcestershire Archive and Archaeology Service)

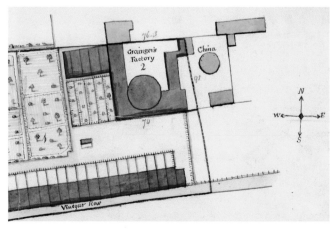

Plan of Grainger's porcelain works in 1824, showing buildings including two circular kiln hovels. The coloured buildings were on land owned by the City Corporation. The works later expanded to the north and east, with new kilns added, including the excavated one illustrated above. (Worcester City Council: 1824 city plan book, Worcestershire Archives (BA 5182). Reproduced courtesy of Worcester City Council)

Dig 20

The New Cathedral Square (2015)

Lich Street Revived

Long-mooted proposals to remodel the space in front of the cathedral finally came to fruition in 2015. A key part of Worcester's traffic system, the roundabout at the junction of College Street, Deansway and the High Street was built in the late 1960s. Just a decade later, the High Street was pedestrianised, and the roundabout became a redundant eyesore. Yet, such is the persistence of these type of features in the urban landscape that it took thirty-five years to remove it.

Cathedral Square lies in the very heart of Worcester, within the Roman defences and on the edge of the Anglo-Saxon and medieval cathedral precinct. It was expected to have very high archaeological potential. It Is also on one of the county's busiest traffic routes, the A44, which carries east–west traffic through the city centre. Closing this road, even for a short while, would be out of the question, so excavation would need to go ahead on an island completely surrounded by traffic. Furthermore, public interest was expected to lead to a demand to see the work at close quarters. Safe ways had to be found to get people into the site to view the excavation.

The area enclosed by the Roman defences has seen little archaeological investigation, with few opportunities from development. Over much of the area the Roman remains are very deeply buried, often below large medieval buildings. The first Anglo-Saxon cathedral was not far to the south, and the Roman defences were reused in the 800s against the Danes. The medieval cathedral precinct boundary crossed the site, just to the south of the now-destroyed Lich Street. The northern part of the precinct was occupied by Worcester's main medieval cemetery. There was a possibility that remains of College Grates, one of the cathedral gatehouses, might be found; the gatehouse had been demolished during clearance for the creation of College Street at the end of the eighteenth century.

An evaluation in 2003 had investigated the centre of the roundabout. At the same time a small trench was dug to test for the remains of College Grates, under lights during the small hours of a Sunday morning. Unfortunately, the signals seen on a radar survey proved to be from a modern concrete manhole rather than a medieval sandstone gatehouse!

In the event, a combination of engineering and economic factors meant that relatively little of the site's archaeological potential was realised by excavation. Road levels were

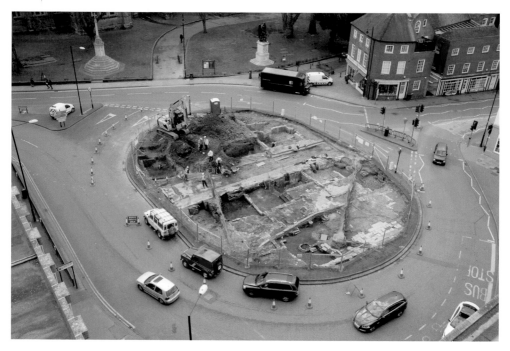

View of the Cathedral Square excavation, looking from the Cathedral Square (former Lychgate) shopping centre towards the war memorials marking the Cathedral's former burial ground. Lich Street, flanked by pavements, crosses the centre of the excavation. (Reproduced courtesy of Worcestershire Archive and Archaeology Service)

raised and construction methods redesigned. Nearly all remains on the site have been preserved; while they were not excavated during this scheme, they should be available for future generations to investigate. Stone and brick cellars were carefully backfilled with concrete so that they can be reopened without damage. This scheme showed engineers and archaeologists working well together to solve problems, protecting remains, reducing impact and also costs.

There were many cellars on the site, mostly dug for the new houses of College Street and the western end of Lich Street at the turn of the nineteenth century. Some dated back to the seventeenth century, and their walls included reused architectural stonework and early roof tiles. In between the cellars, earlier remains could be seen.

There was no opportunity to investigate the rare exposures of Roman remains in detail, and they remain safely buried. The same is largely true for medieval and early post-medieval remains. Although some medieval burials were noted, they were left undisturbed.

No. 5 Lich Street, on the north side, was attached to No. 2 High Street, and there was a stable on the plot in the sixteenth and seventeenth centuries. A pit here contained an interesting assemblage of pottery and glass, dated to the years either side of 1600. Finds included glassware, painted earthenware, and a stoneware jug made at Frechen in the Rhineland. Documentary evidence links this plot with the Parton family, who had a shop on the High Street. Could the glassware have been damaged shop stock?

A very moving element of the project was the literal re-emergence of Lich Street into public view. The medieval street was completely swept away in the 1960s to make way

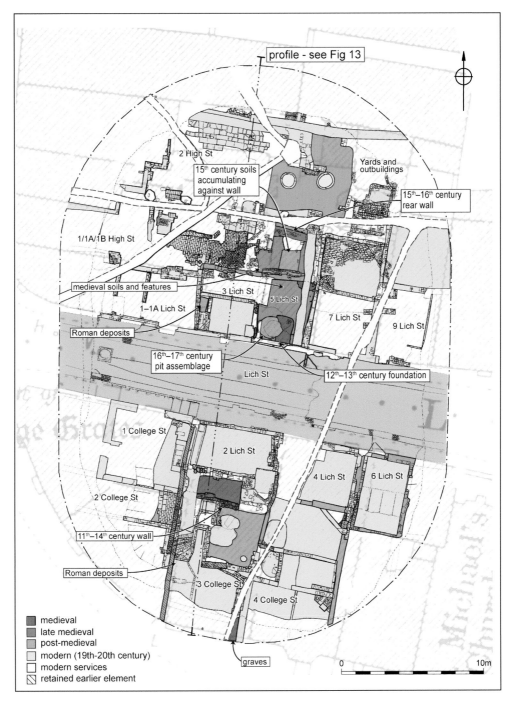

Plan showing excavated features of all periods at Cathedral Square, overlaid on a First Edition Ordnance Survey map of the 1880s. The dominant features are the cellars of the nineteenth-century and earlier houses. Small areas of Roman and medieval remains can be seen in between them. (Reproduced courtesy of Worcestershire Archive and Archaeology Service; map Crown Copyright)

6

Made from a piece of fallow deer antler, this object has been identified as a lucet, an implement used in the making of square-sectioned braid or cord. This lucet is probably medieval in date, but could be later. (Reproduced courtesy of Worcestershire Archive and Archaeology Service)

Photographs of fragments and drawn reconstructions of three glass flasks and a small phial from a pit at No. 5 Lich Street. These were probably the property of the Parton family, around 1600. The probate inventory of Elizabeth Parton, the owner of this property who died in 1574, included numerous household pots, as well as luxury goods in her shop. (Reproduced courtesy of Worcestershire Archive and Archaeology Service)

for the Lychgate shopping precinct. Grand timber-framed buildings had degenerated into slums, and all were demolished, along with the medieval cathedral lychgate. Alongside the excavation, the Worcestershire Archives undertook an oral history project. Interviewees included several former residents, most of whom had left Lich Street when they were small children. Along with the cellars of the demolished buildings, the last street surface had been buried below the roundabout. Some of the interviewees had the chance to visit the excavation and to walk along the tarmac of the street which they had known as children, more than fifty years before.

Oral history was an integral part of the Cathedral Square project and included interviews with people who had lived in Lich Street, some of whom had grown up in the houses being excavated. Recordings are now kept in the Worcestershire Archives. (Reproduced courtesy of Worcestershire Archive and Archaeology Service; map Crown Copyright)

Further Reading

Reports on many of the digs have been published *in Transactions of the Worcestershire Archaeological Society*. The Third Series volumes include reports on the following: Digs 3 and 4 ('The Origins of Worcester', Vol. 2, 1968–69); Digs 5 and 6 ('Medieval Worcester', Vol. 8, 1980); Dig 6 (Vol. 13, 1992); Dig 7 (Vol. 14, 1994); Digs 6, 10 and 11 (Vol 18, 2002); Dig 9 (Vol. 19, 2004); Digs 16 and 17 (Vol. 24, 2014); Dig 15 (Vol. 25, 2016); Digs 18 and 20 (Vol. 27, 2020).

The online Worcestershire Archaeology Research Reports for Digs 15, 16, 18 and 20 are available at the Archaeology Data Service (doi.org/10.5284/1050886).

A great deal of information from Worcester's Historic Environment Record is available online at Know Your Place Worcester (kypworcester.org.uk) and on Heritage Gateway (heritagegateway.org.uk).

Published (and some unpublished) reports and much other material can be researched at the Hive (the library for Worcester), which also hosts the county archives.

Allies, J., *On the Ancient British, Roman, and Saxon Antiquities and Folk-lore of Worcestershire*, 2nd edn (1852) [Dig 1]

Baker, N. J. and R. A. Holt, *Urban Growth and the Medieval Church: Gloucester and Worcester* (Aldershot: Ashgate, 2004)

Barker, P. A., C. Romain and C. Guy, *Worcester Cathedral: A Short History*, 3rd edn (Almeley: Logaston, 2007) [Dig 7]

Boucher, A., *Worcester Magistrates Court: Excavation of Romano-British Homes and Industry at Castle Street*, British Archaeological Reports, British Series, 658 (Oxford: 2020) [Dig 10]

Bradley, R., *Archaeological Investigations at Cathedral Square, Worcester*, Worcestershire Archaeology Research Report No. 9 (2017) [Dig 20]

Bradley, R., C. J. Evans, E. Pearson, S. Richer and S. Sworn, *Archaeological Excavation at the Site of The Hive, The Butts, Worcester*, Worcestershire Archaeology Research Report No. 10 (2018) [Dig 18]

Butler, S. and R. Cuttler (eds), *Life and Industry in the Suburbs of Roman Worcester*, British Archaeological Reports, British Series, 533 (2011) [Dig 18]

Dalwood, C. H. and R. E. Edwards (eds), *Deansway, Worcester. From Roman Small Town to Medieval City*, Council for British Archaeology Research Report, 139 (York: 2004) [Dig 8]

Davenport, P., *Excavations at Newport Street, Worcester, 2005: Roman Roadside Activity and Medieval to Post-Medieval Urban Development on the Severn Floodplain*, Cotswold Archaeology Monograph 4 (Cirencester: 2015) [Dig 13]

Fleming, R., *Britain After Rome: The Fall and Rise, 400–1070* (Penguin, 2010)

Gelling, P. S., 'Excavations by Little Fish Street, Worcester, 1957', *Transactions of the Worcestershire Archaeological Society*, 2nd series, 35 (1958), pp. 67–70 [Dig 2]

Hughes, P. M. and A. Leech, *The Story of Worcester* (Almeley: Logaston, 2011)

Hulka, K., *The Former Worcester Royal Infirmary, Castle Street, Worcester, Worcestershire (Historic Building Non-technical Record Report)*, Worcestershire Archaeology Research Report No. 12 (2018) [Dig 15]

Lubin, H., *The Worcester Pilgrim* (Worcester: Worcester Cathedral Publications 1, 1990) [Dig 7]

Richardson, L. and P. F. Ewence, 'City of Worcester College for Further Education: Its Geology and Archaeology', *Transactions of the Worcestershire Naturalists' Club*, 11, Part IV, for 1960–61 (1961), pp. 226–234 [Dig 2]

Russell, H. S., 'Site of Former Market Hall, Now City Arcade, Worcester', *Transactions of the Worcestershire Naturalists Club*, XI (1959), pp. 165–66 [Dig 9]

Shearer, D. R., 'A note on the Discoveries at the Market Hall Site, Worcester, 1955–56', *Transactions of the Worcestershire Archaeological Society*, New Series, 34 (1957), pp. 54–67 [Dig 9]

Sworn, S., C. H. Dalwood, C. J. Evans and E. Pearson, *Archaeological Excavation at the City Campus, University of Worcester, Worcester*, Worcestershire Archaeology Research Report No. 2 (2014) [Dig 15]

Wainwright, J., *Archaeological Investigations in St John's, Worcester*, Worcestershire Archaeology Research Report No. 4 (2014) [Dig 16]

Western, A. G. and T. Kausmally, *Osteological Analysis of Human Remains from the Worcester Royal Infirmary, Castle Street, Worcester*, Worcestershire Archaeology Research Report No. 3 (2014) [Dig 15]

Willis-Bund, J. W. and H. A. Doubleday (eds), *The Victoria History of the County of Worcester*, Vol. 1 (1901)

Willis-Bund, J. W. and W. Page (eds), *The Victoria History of the county of Worcester*, Vol. 2 (1971)

Worcester City Council, 'An outline resource assessment and research framework for the archaeology of Worcester', https://www.worcester.gov.uk/component/fileman/file/PDF%0Documents/Planning/Heritage%20and%20Design/Worcester%20Research%20Framework.pdf (2007)

Acknowledgements

I would like to thank my family for putting up with the very lengthy gestation of this book.

Originals of many of the illustrations in the book (most of the images for thirteen of the digs) were provided by Worcestershire Archive and Archaeology Service, where Laura Templeton was extremely helpful in finding photographs, plans and other images. Sheena Payne-Lunn of Worcester City Council's Historic Environment Record also tracked down and provided numerous images.

Grateful thanks are due to the many copyright holders for providing images, in most cases free of charge. As well as Worcestershire Archive and Archaeology Service and Worcester City Council, the following are acknowledged: Peter Barker (estate of Philip Barker), Anna Meredith (estate of Michael Meredith), Jane Evans, Phil Shearman, Andy Boucher (Headland Archaeology), BAR Publishing, Mike Napthan (Mike Napthan Archaeology), Christopher Guy and David Morrison (Worcester Cathedral), and the Dean and Chapter of Worcester Cathedral, Deborah Fox and David Nash (Museums Worcestershire), Martin Watts (Cotswold Archaeology), Adam Stanford (Aerial-Cam), Gaynor Western (Ossafreelance), and Ron Thompson and Julie Edwards (Planet Art).

The generous provision of materials to the public domain by the British Museum and National Library of Wales is also acknowledged.

Many thanks also to Steven Wood-Matthews, Garston Phillips, Clive Beardsmore, Stephen Price, Naomi Taylor and Nigel Baker for assistance.